SECRET STIRLING

Gregor Stewart

AMBERLEY

First published 2019

Amberley Publishing
The Hill, Stroud
Gloucestershire, GL5 4EP

www.amberley-books.com

Copyright © Gregor Stewart, 2019

The right of Gregor Stewart to be identified as the
Author of this work has been asserted in accordance
with the Copyrights, Designs and Patents Act 1988.

ISBN 978 1 4456 8786 5 (print)
ISBN 978 1 4456 8787 2 (ebook)

British Library Cataloguing in Publication Data.
A catalogue record for this book is available from the
British Library.

Origination by Amberley Publishing.
Printed in Great Britain.

Contents

Introduction 4

1. The Origins of Stirling 6

2. Stirling During the Roman Period 11

3. Stirling During the Pictish Period 20

4. Birth of a Nation 26

5. Stirling in the Middle Ages 30

6. The Battles for Stirling 34

7. Stirling and the Reformation 45

8. Oliver Cromwell in Stirling 62

9. The Stirling Witch Trials 74

10. The Growth of Stirling 86

Bibliography 95

About the Author 96

Introduction

Stirling is a young, vibrant city known for being a centre of tourism and learning. Yet, as you wander through the city centre you are surrounded by ancient buildings with a long history and significant historical importance.

As with many early settlements, Stirling began as a tiny settlement, at the lowest crossing point for the River Forth. This both aided water supplies and transportation of goods, while the nearby rocky outcrop provided a strong defensive position to protect against enemy invaders. The importance of the Forth crossing could not be underestimated, with Stirling deriving its name from the most early turbulent times as this was fought over.

A royal charter was granted to the town in the twelfth century, bringing new rights and powers to the residents; yet with the bridge remaining one of the most fought over

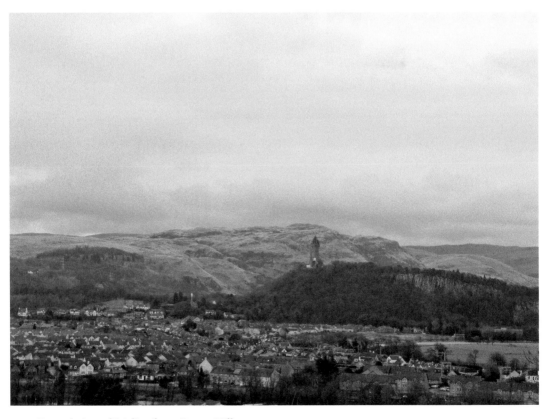

General view of Stirling from Gowan Hill.

crossings in Scottish history, the charter did not bring peace to the area. It has long been said 'He who holds Stirling, holds Scotland', resulting in the castle being one of the most sieged in Scotland, and some of the most famous battles in Scottish history being fought around Stirling.

Eventually more peaceful times did arrive, but Stirling remained a relatively small market town until the nineteenth century when it started to benefit from significant improvements in living standards. By the end of the century the town's historical importance was once again being recognised, allowing the tourist trade to build, aided by Stirling being considered to be the 'Gateway to the Highlands'.

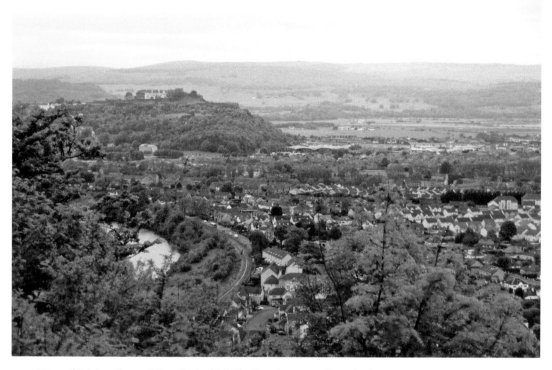

View of Stirling from Abbey Craig. (© Mike Pennington, cc-by-sa/2.0)

1. The Origins of Stirling

The settlement that would grow to become modern-day Stirling can trace its origins back for several centuries. The location was chosen for defensive reasons, with it being the lowest crossing point for the River Forth before it widens out into the Firth of Forth and ultimately the North Sea. Those who controlled the crossing points would yield great power in the area.

Gowan Hill offered a prime location to oversee the crossing point and watch out for invaders approaching from all around. Initially it is believed a single tower stood here, known as a Dun. This Dun was initially known as Sna-Dun, before developing to Snawdun and eventually Snowdoun. As the settlement grew, the name changed to Striveling, which means 'place of strife', an indication of how fiercely this vital crossing was fought over, and it is from this that the name Stirling is derived.

A discovery made on 6 January 1879 in the Coneypark area revealed just how long a settlement has existed at Stirling. A paper written by James K. Thomson AMA tells that Drummond's Nursery occupied the site at the time, and that while digging gravel from a seemingly natural mound an unusual stone arrangement was uncovered. Further investigation revealed this to be an ancient stone cist, and the then newly formed Stirling Field Club were invited in to carry out an investigation. They found that the cist had been formed from a gravel base, with stone slabs placed on their edges to form the sides and a larger slab on top, with reddish clay applied to the corners to seal the chamber. Within, they discovered the skeletal remains of a human body, which were removed and gifted to the Smith Art Gallery and Museum.

The burial cairn was largely forgotten and the nursery continued to operate around it until 1969, when the land was sold for a new housing development. Before construction work could start, the Stirling Field and Archaeology Society were granted permission to carry out limited excavations to locate the original burial site, with the intention that this should be retained as a feature of the new housing estate, and to find the burial cist documented from the 1879 exploration of the area, along with the extent of the wider cairn.

The location was found to be on the edge of the former planting bed used by the nursery, and formed a low, oval mound measuring approximately 27 meters by 16 meters. The top of the mound was relatively level, with the exception of a hollowed out area to the south-east that was later revealed to be the area where the gravel had been dug, revealing the cist in 1879. A large number of stones were littered around, indicating that burials may have been inadvertently disturbed, and several trees and bushes were growing on the top of the mound. A tree-preservation order limited the extent of excavation that was possible and were initially limited to where the original cist was found, but as this had not been documented a degree of guesswork based on the visual evidence was required, concentrating on the hollowed area.

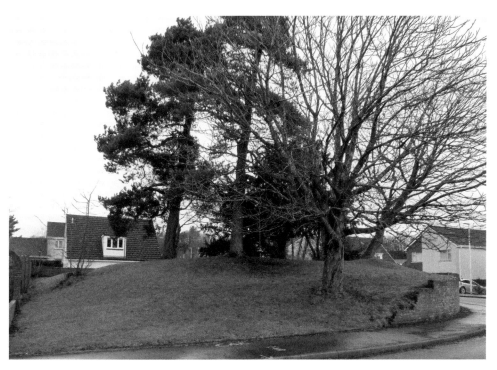

Burial cairn within a modern housing estate.

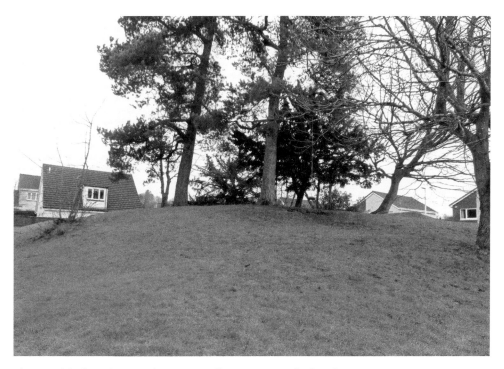

The top of the burial cairn, where trees still grow, causing further damage.

What is perhaps more remarkable is that the findings at Coneypark were part of a much larger cemetery, which extended across the Birkhill and Cambusbarron area, now intercepted by the M9. Unfortunately, the locations of the other burials were not accurately recorded and so are no longer known, although the contents of some of the cists and approximate positions are noted as follows:

Birkhill House

Two mounds within the grounds were excavated. The west mound was dug pre-1880 and although a cist was found, the contents are not documented. In 1880, a cist in the east mound was uncovered and found to contain human bones and a food vessel.

Douglas Terrace Area

A cist was found in 1886 that contained parts of an urn.

Birkhill Sandpit

The bottom slab of a cist was discovered in 1905, although the contents had been lost.

Turning our focus back to the cists at Coneybank, the main human remains found within the first cist were believed to be that of an adult male, aged in his mid-twenties. The damage caused to the right side may be an indication of the cause of death, with the bones of the right leg showing signs of burning, although it was common for bodies to be cremated in the later Bronze Age. The lesser remains were found to be that of either an adolescent or possibly a slightly built adult, no more than twenty-three years of age, again with signs of burning to the bone. The bone fragments from the second cist were found to be from a child, aged between four and five years old, leading to some speculation that the second body found in the first cairn was a woman, possibly making this a family burial.

That is not the end of the story, however. In 2017, the bones removed from the cist discovered in 1872 were radiocarbon-dated and it was found that the bones were from between 2152 and 2021 BC, making the body more than 4,000 years old. Over a six-month period, archaeologist Dr Murray Cook, Michael McGinness of the Smith Art Gallery and forensic artist Emily McCulloch studied the relics. A facial reconstruction based on the skull was completed by Emily to show what the man would have looked like, and 'Torbrex Tam', as he affectionately became known, has been officially declared as Stirling's oldest resident.

DID YOU KNOW?
Although it only gives the appearance of a small mound, the burial cairn in Coneypark is the oldest structure in Stirling.

It was known from the original reports that the capping stone was left in place and that the skeletal remains had been recovered by removing one of the side stone slabs, which was found to be the case when the cist was revealed, albeit that the orientation was found to be slightly different. With the location of the cist known, efforts were made to establish the extent of the burial cairn that had covered it, a task that was hampered due to its earlier use for gravel and damage caused by tree roots, including what seems to have been a large tree that had some point fallen over. As a result, the full extent of the cairn could only be estimated to have had a minimum diameter of 12.75 meters. While tracing the cairn, a second cist was discovered, constructed in a similar manner from stone slabs. A list of the contents of both cists was taken, including the reassessment of the remains removed from the first cist in 1879, when it was found that the bones had in fact come from two individuals. The finds were as follows:

Cist 1
The skull of the first body, with a large part of the right side missing. Four teeth remained in position in the upper jaw. The right-hand side and chin of the lower jaw with six teeth still in position, the left femur and left tibia, along with part of the right femur and tibia. In addition, three fragments of a skull from a second person were found, along with the right side of the lower jaw, with two teeth in position.

Cist 2
A fragment of skull, along with two crowns and other tooth fragments. This cist also contained a beaker with rough decoration cut into the main body.

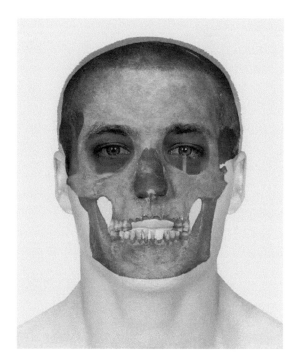

Right and overleaf: The facial reconstruction of Torbrex Tam. (Photo supplied courtesy of Emily McCulloch)

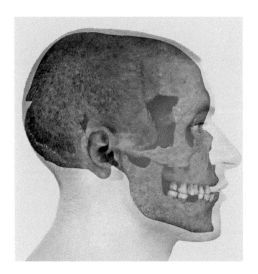

2. Stirling During the Roman Period

The Roman armies arrived in modern-day Great Britain in the year AD 43. Initially landing in Kent, they wasted no time in marching north, seizing control of vast areas of the country as they went. While they showed no mercy to those who opposed them, the Romans were not seeking to destroy Britain; instead, they were after the vast mineral and metal resources of our island, and areas under Roman control had significant infrastructure built, including forts and a network of roads.

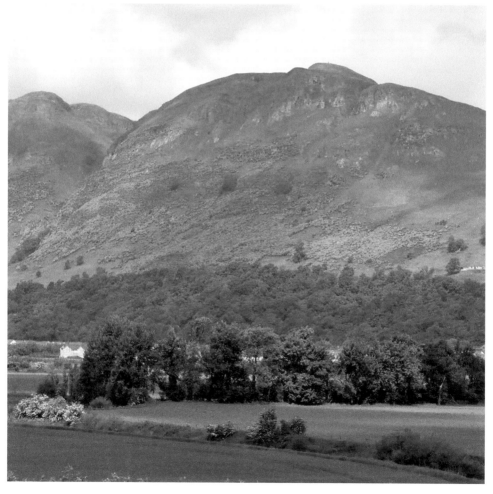

Dumtay Hill from near Tullibody. (© Alan Murray-Rust, cc-by-sa/2.0)

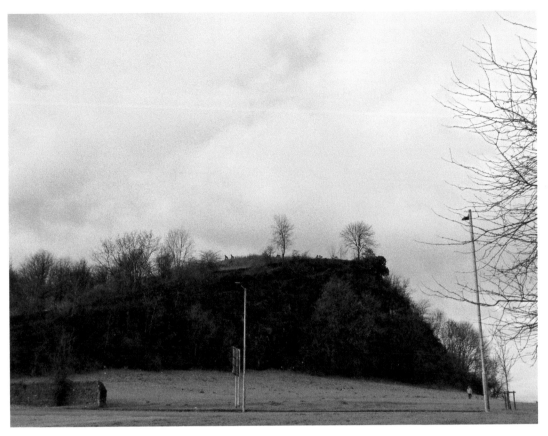

The tip of Mote Hill, where the Maeatae tribe were believed to hold a hill fort.

At the time of the Roman invasion, Scotland was divided into a number of small regions and kingdoms, each with their own tribes and rulers. Although the names of many have been lost, the Stirling area was occupied by a tribe known as the Maeatae, who dominated the region with a number of strongholds. It is from one of these, a hill fort on the Dumyat hill, which overlooks modern Stirling, that the name of the tribe is known – Dumyat being derived from the Gaelic, Dun Mhead or Dun Maeatae, meaning 'Fort of the Maeatae'. In addition to this hill fort, the tribe are believed to have had a significant fortification on the northern tip of Gowan Hill, known as Mote Hill.

By the mid-first century, the Romans had advanced to southern Scotland. At some time between the years AD 70 and 80 a number of forts were built on the Gask Ridge. Although not interconnected, this row of forts is the earliest known Roman frontier in Scotland, predating Hadrian's Wall by around forty years. It is known to run from just north of Dunblane to just above Perth, although it may have been part of a longer frontier extending as far as Strathcathro in Angus. It was a significant detour to march around the River Forth, which in itself carried extra risks for the Romans in moving significant forces and supplies north. The crossing points were therefore becoming increasingly vital, yet they remained well defended by native tribes, including the Maeatae.

Perhaps as a sign of the importance placed on the crossing at Stirling, this area had a number of forts built around it. In the year AD 77, Gnaeus Julius Agricola was appointed the Roman Governor of Britain, and he is believed to have been responsible for the construction for many of these forts. Approximately 11 miles south of Stirling at Castlecary, a significant fort stood on high ground. Extending to several acres, the fort was surrounded by a stone wall with several buildings protected within. In 1770, workmen were employed to search the site for stones to be used in the construction of the Forth and Clyde Canal, which passes just north of the site, and rediscovered some of the buildings under the rubble and earth. Although some of the findings, which included what appeared to be a bathhouse, were noted, the stones were not deemed to be suitable for the purpose

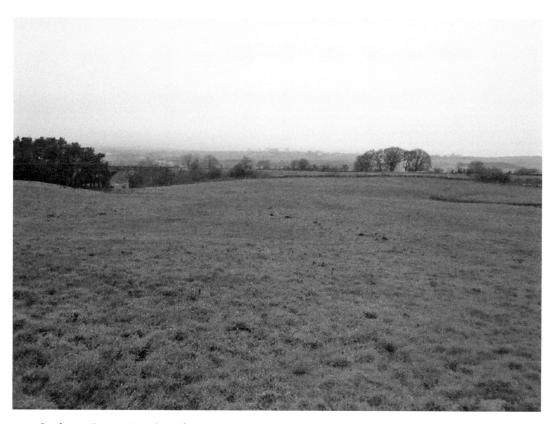

Castlecary Roman Fort. (© Robert Murray, cc-by-sa/2.0)

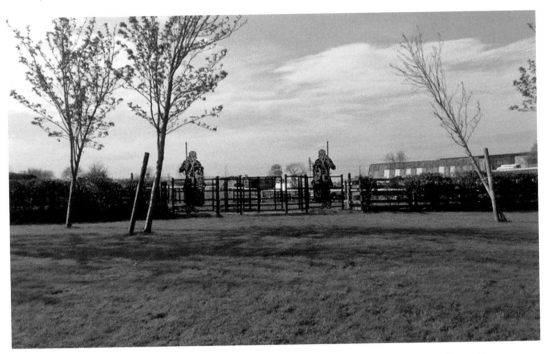

The two Roman soldiers guarding the gate marking the entrance to the site of the Castlecary Roman Fort. (© Euan Nelson, cc-by-sa/2.0)

of building the canal, and so the exploration was abandoned. In August 1771, the site was once again quarried, and on this occasion a large hollow was found, believed to have been a wheat store, along with iron wedges and hammers.

Just 2 miles east of the fort at Castlecary, another fort stood at Rough Castle, not far from where the Falkirk Wheel can now be found. This was a smaller, square structure, surrounded by an earth wall and double ditch for defence. Inside there is evidence of a stone praetorium (where the general would have stayed), although the site has been historically quarried to build the surrounding houses.

The forts at Castlecary and Rough Castle are believed to have been part of a row of such defences; however, a short distance in front of the line that they would have formed, the remains of a further camp exist at Camelon. In historical books this camp has been described as a 'moderate city', surrounded by ditches and walls, even having streets within dividing up the buildings, although there is some debate whether these streets were in fact the Roman road that passed through rather than anything to do with the settlement. Although the full extent of Camelon could not be determined due to the site being farmed for centuries, cut stones from the Roman era have been discovered a considerable distance from the remains of the ramparts.

It is though that it is from the camp at Camelon that General Agricola marched his forces north in order to launch an attack on the crossing of the Forth. Exactly what happened in the vicinity of modern-day Stirling is not known, but it is certain that General Agricola successfully crossed the river and proceeded north. Snippets of

The Antonine Wall from the Roman fort at Rough Castle. (© Lairich Rig, cc-by-sa/2.0)

View towards Rough Castle Fort. (© Lairich Rig, cc-by-sa/2.0)

information from his campaign to take Britain can be used to piece together some information on the Roman occupation of Stirling. In AD 83, the general's forces faced Caledonian forces led by Calgacus at the Battle of Mons Graupius – one of the most decisive, yet relatively unknown, battles of Scottish history. The location of this battle is uncertain and much disputed. The name would indicate it was somewhere in the region of the Grampian Mountains, although it is unlikely that Agricola would have led his forces over these harsh and dangerous summits. A description given of there being nothing visible but rocks and sea beyond the battle site has made many suggest the forces met close to the Moray Coast.

The Roman forces were massively outnumbered by the Caledonians, and were no doubt exhausted from their march north. The Caledonians were gathered from a number of tribes however, and despite their confidence at their higher numbers, their lack of discipline resulted in them being no match for the highly trained and organised Roman army. After a decisive win and seeing nothing but the ocean in front of them, the Romans incorrectly believed they had finally conquered the whole of Britain, and though Agricola sent some of his army sailing around the top of Scotland, he returned south. The Roman senator and historian Publius Cornelius Tacitus tells that General Argicola had defences built between the Firth of Forth and the Firth of Clyde. This was said to have included a fortification on Motte Hill, the site of the Maeatae stronghold, and he is also credited with creating a road, artificially cut between two hills on the north side of the current castle. General Agricola was recalled to Rome in AD 85, and with the growing threat from both the Caledonians and the Picts, the main natives of the country beyond the Forth, the Romans sought the safety of the south of the River Forth.

DID YOU KNOW?
According to a work published by the London Society of Antiquaries in 1795, a number of anchors have been found in the region of the Camelon Roman Fort, along with a complete boat around 5 fathoms deep in the clay, showing the importance of the area as a port.

Further attempts were made by the Romans to take Scotland, with the best known being led by Publius Aelius Hadrianus, better known simply as Hadrian, who had his famous wall constructed from AD 122 to protect the Roman Empire from the Picts. His successor, Emperor Antoninus Pius, appointed Quintus Lollius Urbicus as Governor of Britain, and although the emperor never visited Britain himself, he did order Lollius to launch further attacks beyond Hadrian's Wall before having the Antonine Wall built – from the year AD 142 – between the firths of the Forth and the Clyde. It is documented that Lollius had a residency in the area where Stirling Castle stands and that an inscription, although now worn away, was carved into rocks opposite the castle gates, telling that the Roman 11th Legion were stationed there to keep watch.

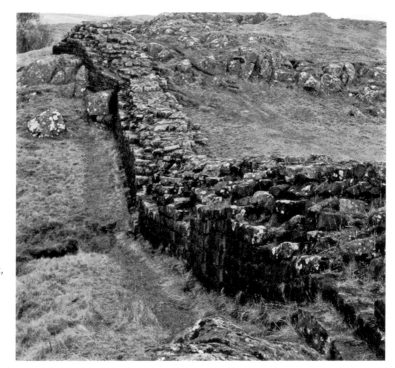

A section of Hadrian's Wall that, although intact, is much smaller than its original size. (© Mary and Angus Hogg, cc-by-sa/2.0)

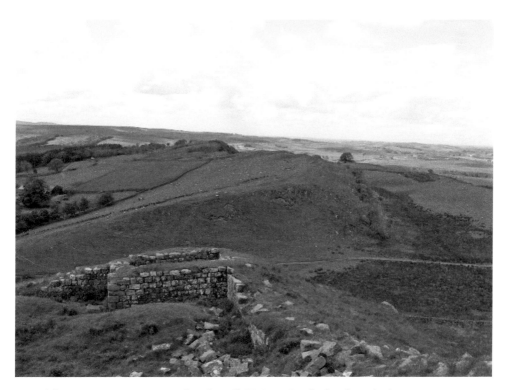

One of the surviving turrets on Hadrian's Wall. (© Dave Dunford, cc-by-sa/2.0)

A section of the base of the Antonine Wall at New Kilpatrick Cemetery. (© Lairich Rig, cc-by-sa/2.0)

Rampart and ditch of the Antonine Wall near Falkirk. (© M J Richardson, cc-by-sa/2.0)

The third century once again saw Roman forces in Stirling, this time led by Emperor Septimius Severus, who is also said to have spent time at the Roman fortifications in Stirling in the year 207. At that time it is documented that his forces met the Maeatae, described as being the race who live next to the 'cross wall' – this is believed to be a reference to Antonine Wall, which divided the country in half. It is clear that whatever had happened during the times of General Agricola that the Maeatae had once again grown to become a force to be reckoned with. His successor, Emperor Caracalla, withdrew the Roman forces to behind Antonine Wall, leaving the region of Stirling once again in the hands of the Maeatae. It would appear they instinctively utilised the former Roman fort at Gowan Hill as around the year 250 it is said this was destroyed, once again by an invading Roman army. By the year 290, the Roman Emperor Constantine the Great seems to have finally quelled the threat from the Maeatae, yet their place was taken by the Picts, who continued to oppose the Roman invaders, denying them the claim to have seized control of the whole of Britain.

Evidence of the Roman fort on Gowan Hill is believed to have existed into the eighteenth century, possibly even later, with mounds covering the walls that were said to be tall enough to have still hidden a horse and cart behind.

DID YOU KNOW?
During the third century, Emperor Septimius Severus accompanied his invading army to Scotland, staying at the Braco Fort. At that point, according to the rules of the Roman Empire, the capital was wherever the emperor was. Braco, near Stirling, was therefore considered the capital of the Roman Empire for a few weeks.

3. Stirling During the Pictish Period

Accurate information on the Pictish period of Scottish history is somewhat difficult to find for two main reasons: the first being that the Picts kept very few written records, and the second being, as a consequence of the lack of records kept by the Picts, much of what we do know is written by their foes, mainly the Romans, and so it is heavily one-sided. In fact the name 'Picts' itself was given to the people by the Romans, with the first appearance of it being from the year 297; it means 'Painted People', based on their tradition to cover themselves in war paint. The few written records left by the Picts tend to take the form of cave carvings. There are several good examples still preserved today, although their meaning is largely unknown.

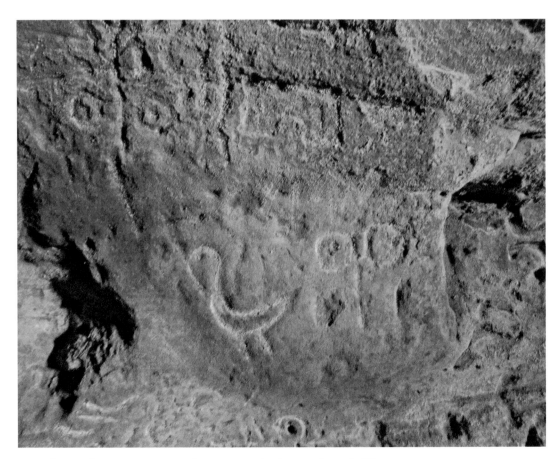

Above and opposite page: Pictish carvings at the Wemyss Caves in Fife.

The Picts came together through the joining together of many northern tribes to oppose their common enemy – the Romans. Constantius Chlorus was the last emperor of Rome to try to push into the far north, yet by the year AD 306 he had largely retreated to behind the safety of Hadrian's Wall. King Vipoig, who reigned from 312 to 342, is the first documented King of the Picts, with his kingdom stretching from the River Forth to the lower Highlands. He is known to have had a hill fort close to the city of Dundee on the banks of the River Tay, possibly around the port built by the Romans on the river during their invasion in the first century. Abernethy in Fife was the main residence for the Pictish kings, yet by the year 360, with Rome weakened, the Picts along with their new allies, the Gaels from Ireland, were launching attacks deep into Roman territory, even across Hadrian's Wall. This was aided in the winter of 367 when the garrison protecting Hadrian's Wall rebelled against their commanders and allowed the Picts to cross – an act that became known as the Great Barbarian Conspiracy. The military leader Theodosius the Elder was brought in by Rome to once again push the Picts back, but while he was successful initially, it was short-lived.

At the start of the fifth century it is written that a great battle took place between the Picts and the Romans just 7 miles from Stirling centre, fought on the banks of the River Carron, close to the village of Dunipace. The Pictish forces were commanded by Fergus II. The Romans ultimately won, but it was at a very heavy cost to both sides. The battle raged for a considerable time and the slaughter was so great that it was said the waters of the river turned red with blood for several miles. By the year 411, Roman control of the region had completely failed and the legions departed, resulting in the Picts and Gaels resuming their assault into the territory of the Britons. With Rome failing to respond to their requests for assistance, the Britons instead brought in help from the Angles and the Saxons to help defend themselves.

Discoveries made as recently as 2002 helped shed some light on the importance of Stirling during this period. *The Telegraph* reported that while digging trenches to lay floodlights at the base of the Wallace Monument to illuminate the structure at night, workmen discovered the remains of a structure that archaeologists determined were the remains of a structure dating back to the Dark Ages. Further exploration revealed stone walls, ramparts and entrances dating from around AD 500 to 780 indicating what was described as a citadel, providing evidence that Stirling was an important centre of power during this time – possibly the capital.

Other sites suggested as centres of power have included Stirling Castle, yet the discovery on Abbey Craig Rock is said to bear remarkable similarities to other known important settlements of the time, and the rock itself offers one of the best vantage points in the region. The stone ramparts were found to be still laced with timber and flagstones were found to have been placed along the top, enabling a lookout to patrol the perimeter of the fort. It was noted that the authorities of the time, including the king, would move around and, with the significance of the structure overlooking such an important route from the south of Scotland to the north, it was concluded that it is highly likely the discovery was one of the main capital towns of the time.

Meanwhile, the Northumbian kingdom expanded through modern-day southern Scotland up to the banks of the River Forth, with much of Stirling, including the castle site, falling under the control of the Northumbrians. These two key observation and defensive points faced each other across the river, occupied by opposing forces. In the year 603, King Aedan deemed the threat to be too great and, uniting the east and west of Scotland, he formed an army of both Scots and Pictish warriors and marched against the Northumbrians. It was a huge miscalculation and Aedan was defeated, with two of his sons killed in the battle. The king's fate is not known; he is not mentioned again until around six years later, when it was reported he had died. The Angles's response to this

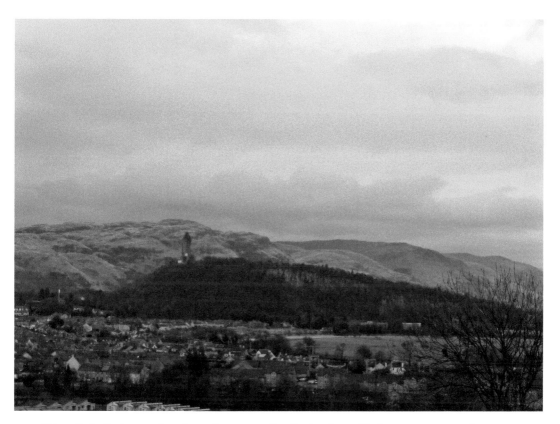

Abbey Craig Rock, towering above the surrounding flat land, provided a great vantage point.

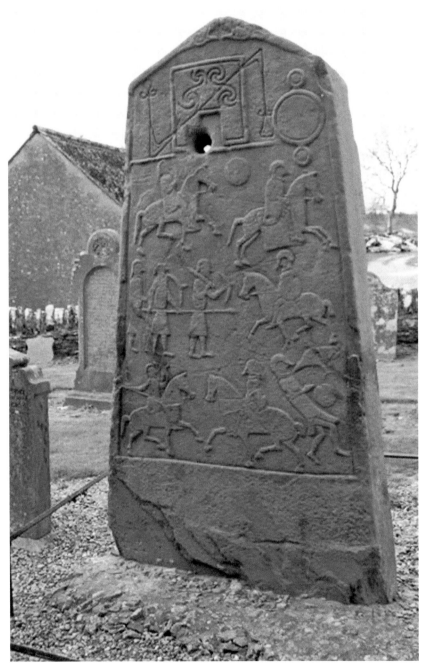

The rear of a Pictish carved stone in the grounds of Aberlemno Kirkyard, near Dundee, is believed to depict the Battle of Dunnichen. (© Andrew Wood, cc-by-sa/2.0)

attack was swift and decisive. They marched north, taking control of the land between the River Forth and the River Tay. Although not documented, it is likely the citadel upon Abbey Craig Rock was taken and held at this time.

Possibly the first great leader in Scottish history soon stepped forward when the Picts turned to King Bridei to lead them in battle against the Northumbrians to regain their territory. Bridei was a skilled soldier, using well-planned tactics, yet was equally brutal in the slaughter of his foes, which had resulted in him already taking control of much of the Pictish territory in the far north. The advancing Angles were a threat to his lands, so he took up the role and led an army south. Upon hearing of the new Pictish forces, King Ecgfrith of the Angles himself rode north, passing through the settlement at Stirling and crossing the Forth there, before joining the rest of his army at the River Tay and moving forwards.

The two forces met just north of Dundee and fought each other in what became known as the Battle of Dunnichen. King Bridei had chosen the location, and sent a small group of men forward so they would be seen by the invading Angles. Believing he was seeing the extent of the depleted Pictish army, King Ecgfrith pursued the fleeing Picts – against the judgement of his advisors – only to come face to face with King Bridei and his full army as they came over the summit of a hill. With a loch and steeper hill restricting the directions Ecgfrith could go, the Picts attacked, slaughtering their enemy. The defeat was so great that it changed the control of Scotland significantly. The remaining Northumbrian army retreated, again through Stirling, and never recovered from their losses. Meanwhile, the Picts entered a period of time when all of the tribes united under a single leader – King Bridei.

DID YOU KNOW?
In 2014, a discovery made by a young metal detectorist in Fife revealed a hoard of silver pieces from the Roman period. Known as hacksilver, as they were small pieces literally hacked off a larger piece of silver, it is believed these were used to pay the Picts for free passage after they passed through Stirling.

4. Birth of a Nation

Some of the best-known figures in shaping Scottish history, such as William Wallace and Robert the Bruce, have strong connections to Stirling, which will be discussed in a later chapter. What is less well known, however, is that one of the most decisive battles in the nation's early history is believed to have taken place in the shadow of Abbey Craig.

During the ninth century, while the Picts remained relatively united, the country was still divided into two nations. The largest region was that of the Picts, which extended from the River Forth northwards, while the west of the country was the territory of the Scots. The two sides often battled for control of the country and the Picts soon found themselves also under attack from the north from the Vikings. Knowing that their forces were fighting off the threat of the Norsemen, King Alpin of the Scots seized the opportunity and marched his army into Pict territory, judging that his foes could only send limited resources to oppose them. Upon hearing of the approaching Scotsmen the Pictish King, Bridei, set up his troops in the hills close to Dundee. Alpin was correct in his judgement: only a small army was sent, but he did not account for Bridei being a skilled tactician. He ordered all of his army's attendants, including women and those too young to fight, to take some of the horses and hide in the hills around the chosen battle site to await further orders.

King Alpin no doubt felt encouraged as he marched into the valley to see the small Pictish army; however, as soon as they did so, King Bridei gave the signal and all of the hidden attendants moved into sight. Seeing themselves surrounded by figures and horses, and unable to make out in the distance that they were not warriors, Alpin's men feared they were surrounded by a massive Pictish army and began to disband and flee. Alpin tried to regain control, but ultimately failed, and both he and his commanders were taken prisoner. All but the king were slain on the battlefield, and there is some suggestion that a ransom was demanded for the safe return of Alpin, but if there was it was not paid. Alpin was beheaded at a site that became known as Pitalpin, believed to be in the region of Camperdown Park.

DID YOU KNOW?
According to legend, during the ninth century Stirling came under a sneak attack from Viking invaders. However a wolf called as they approached, alerting the town guards, who managed to fend off the onslaught. The wolf was adopted as a symbol for the town and the area became known as Wolfcraig.

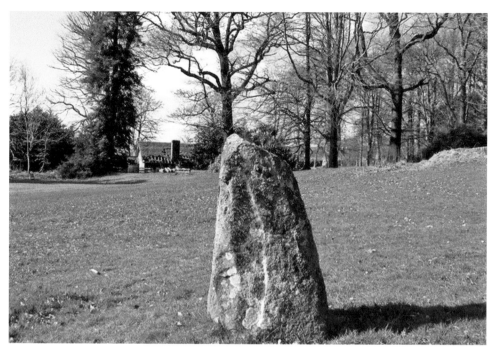

Kings Cross Stone in the grounds of Camperdown House at Dundee is said by some to be where King Alpin raised the standard to signify the start of the battle, and where he was taken to be beheaded.

Sueno's Stone in Forres is the largest surviving Pictish stone, believed to depict the battle and beheading of King Alpin.

While the threat from the Scots had been reduced, the Viking attacks were still very much ongoing, and over the coming years many of the Pictish nobles and leaders had been defeated. King Alpin's son, Kenneth, succeeded to King of the Scots and when King Bridei was killed in a Viking attack he laid claim to the Pictish crown. His claim was based on the Pictish tradition of the heir to the crown being from the female side of the royal family, on the rather crude basis that while you never knew who the father was, you would always know the mother. King Kenneth's mother was a Pictish princess, and his assertion was that he was the most direct heir.

Other members of the royal houses of the Picts however disputed his claim, and the crown was passed to Drust X. In retaliation, Kenneth advanced into Pictish territory to take the throne by force. Stirling at the time was under the control of the Picts and as the Scots forces moved towards the town, an attack was launched by King Drust before they could cross the River Forth. Few details are held of the battle, which would have almost certainly been brutal; yet, despite the surprise nature of the attack, the Scots under King Kenneth were ultimately successful. Seemingly in an attempt to resolve their issues, Kenneth then extended an invite to Drust and the others who had laid claim to the throne to meet to discuss the matter at Scone. This was a ploy to lure the Pictish king and others from the security of Stirling, which became known as MacAlpin's Treason. When the Picts arrived at Scone they were offered drinks, which continued to flow freely, before they all moved to a room where the talks were to take place. Unknown to all present other than King Kenneth, the bench seats had been booby trapped. Once all of his opponents had been seated, trapdoors below them were released. Below the floor, pits had been dug and wooden spikes driven into the ground. With the King of the Picts and all other potential heirs from the royal households perishing in these pits, Kenneth successfully ascended to become the joint King of the Scots and the Picts.

Kenneth's combined kingdom became known as Alba and, having the stronger fighting force, he took the battle to the Viking invaders, forcing them back and into retreat. The Angles of Northumberland continued to fight for the land south of the Forth, including Stirling, yet when faced by the now much larger army of Alba they were slowly pushed back, with the hill fort at Stirling providing the strength and strategic advantage to those who held it. Successive kings continued the fight and in the year AD 973, Kenneth III gathered an army in Stirling that he led to defeat a Viking invasion at Luncarty in Perthshire. Eventually, as territory was reclaimed and enlarged, the current Kingdom of Scotland was forged, largely led from Stirling.

King Kenneth MacAlpin is credited as being the first King of Scotland, having formed the nation by bringing the two crowns together, an act that would ultimately allow the natives to jointly dominate the land. The exact location of his decisive battle with the Pictish forces is not certain, but it is believed to have been where the Stirling University sports fields now are. A large standing stone, measuring approximately 2.7 metres high and known as the Airthrey Stone, is said to mark the spot of the battle. A second stone, measuring approximately 2.8 metres high named the Pathway Stone, which also stands in the grounds of the university, is also believed to be a marker. These together give an idea of the size of the battlefield. The surrounding area became known as Cambuskenneth, which means the 'Field of the Kenneth' and is also believed to relate to King Kenneth MacAlpin's victory here.

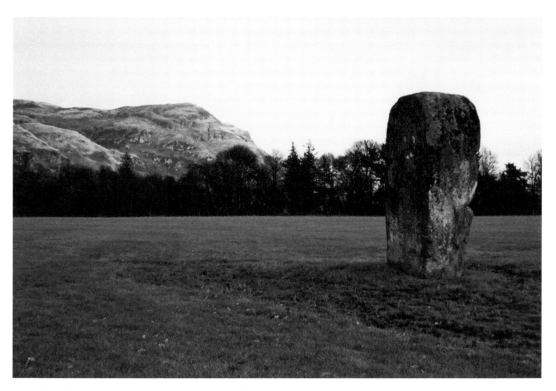

The old standing stone near Airthrey Castle. (© Frank Garvock, cc-by-sa/2.0)

DID YOU KNOW?
When King Donald of Scotland was captured by King Osbert of Northumberland during battle, he gave over all the lands between Stirling and the Clyde in return for his release. King Osbert set up temporary residency in Stirling Castle and started to produce money there. This became known as 'Sterling Money', the name still used today.

5. Stirling in the Middle Ages

While Stirling had played a vital role as a crossing point of the Forth since its origins, it had not been able to utilise the benefits of the river. This was due to both sides of the Forth being held by opposing forces, with each attacking the other sides vessels if they tried to pass. With the Celts and Scots uniting and reclaiming the territory to the south of the river that all began to change, and Stirling grew as a result.

The exact date the royal castle was constructed is not known, although it is known that the castle was in existence during the eleventh century with a large number of wooden huts forming a settlement on the hillside around. The first written records of the castle are from the twelfth century, when in 1107 when Alexander I endowed the chapel to the castle. During the 1120s, David I granted the townspeople of Stirling a royal charter, which formally made the settlement a town, bringing with it certain rights and privileges. The town later became a royal burgh, which allowed it to have a weekly market, with the merchants of Stirling electing a provost to run the town's affairs.

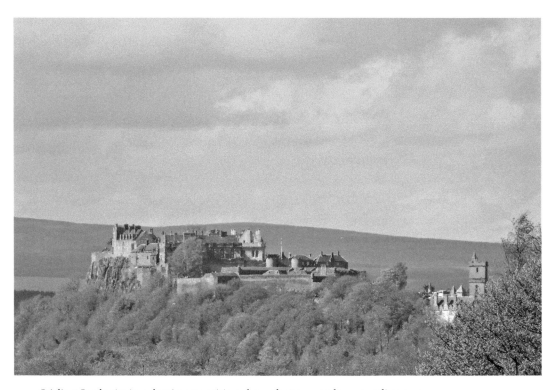

Stirling Castle sits in a dominant position above the town and surrounding area.

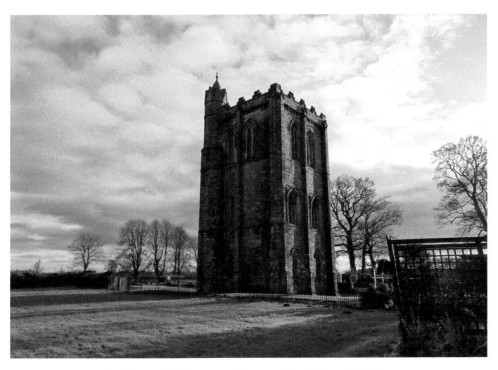

The remains of Cambuskenneth Abbey, originally named the Abbey of St Mary.

In 1139, the second treaty of Durham was signed between King Stephen of England and David I of Scotland, which replaced the first treaty ratified earlier in the same year that granted control of Northumbria and Cumbria to the Scots. The second treaty went further, recognising Scotland as an independent country.

All remained relatively calm between the two nations. Around 1140, King David founded an Augustinian abbey at the village of Cambuskenneth, originally named the Abbey of St Mary or the Abbey of Stirling. A ferry is believed to have operated here, taking worshipers across the River Forth to the abbey and back again prior to the construction of a bridge. As a result, Cambuskenneth Abbey grew rapidly over the next few years and thanks to its royal patronage and association with Stirling Castle, it gained considerable wealth and influence in local and national affairs.

DID YOU KNOW?
The first recorded attempt to fly took place in Stirling. James IV employed Italian alchemist John Damian, who worked from a vault beneath the castle. In 1507, he declared that he had invented a method to fly and, complete with feathered wings, jumped from the castle battlements. Needless to say it didn't work, and he fell to the ground, breaking his thigh bone in the process.

In 1157, by which time Henry II was in power in England, and Scotland was under the rule of the sixteen-year-old Malcolm IV, the uneasy peace between the two nations ended. Henry saw him as a weak king and went against the treaty, summoning Malcolm to Chester where he was persuaded to sign over the lands of Northumbria and Cumbria, much to the dismay of the Scottish nobles. When Malcolm died with no heir at the age of just twenty-four in 1165, he was succeeded by his younger brother, William I, better known as William the Lion. Unlike his brother, William was a strong leader and sought to regain control of Northumberland, which became an obsession of his reign.

A period of a several years followed where the two kings weighed each other up, followed by violence as William tried to retake the area by force. During the Second Battle of Alnwick, in 1174, William became separated from his army and was taken prisoner by the English. In return for his freedom, he was forced to sign over control of parts of southern Scotland, along with several key castles, including Stirling, to the English. In 1189, Henry was succeeded by Richard I, who was desperate for money to join the Third Crusade, so the lands and castles taken by Henry were returned to Scotland in return for a sizeable payment. This was the first of many times control of Stirling Castle would pass to the English and then back again, and one of the few times it was not taken by force.

The thirteenth century saw several changes in Stirling. The original wooden castle was replaced with a much stronger stone structure, and religion moved to the town in the form of the Dominican Black Friars and the Franciscan Grey Friars – the names were derived from the colours of the robes they wore. The friars were different from the monks of the other religious factions because instead of living a secretive life within their own properties, the were a common part of the local community, mixing with the townsfolk to whom they would preach the word of God. A leper hospital was also built just outside the town walls to isolate the infected. It is known a leper hospital once stood around the junction of Kings Park Road and Gladstone Place, although this may have been a later construction.

Cambuskenneth Abbey had also grown considerably during the thirteenth century and covered an expanse of several buildings, including a 60-metre-long abbey church. A cloister stood to the south, surrounded by domestic buildings. A small dock existed at the river for the ferryboats transporting people from Stirling, and another range of small buildings separated this from the main abbey church and cloister. The canons who resided at the abbey had the sole role to worship and pray for their patron, the King of Scotland, and they also had various duties within the royal court to undertake.

DID YOU KNOW?
At the centre of the castle is a paved rectangular courtyard known as the Lion's Den. It is much rumoured that this is where James V kept a pet lion, given to him while in France, which led to the lion becoming an important symbol in Scottish heraldry.

The end of the thirteenth century saw Scotland and England enter into the Wars of Independence. The battles around Stirling will be covered in the next chapter, but suffice to say considerable destruction arrived, with the town and castle both being extensively damaged, rebuilt and changing hands several times. As more peaceful times returned, it became an important market town with an annual fair in addition to the weekly markets. Traders would travel from all over Scotland to sell their goods in Stirling, and in 1447 a second fair was introduced as a sign of the significance of these events. Stirling also grew as an industrial town and port, manufacturing weaving wool that was sent to the export market. In 1415, Stirling's old wooden bridge crossing the River Forth was replaced with a new stone one, known as the Auld Brig, which provided a better connection to the lands to the north.

Despite the importance of Stirling for its defensive role, royal and religious connections, and as a main market town and growing port, the town remained very small compared to towns today. It is estimated that during the fifteenth century the population would only have been between 300 and 500 people, with the settlement outside the castle structure protected by a ditch and earth ramparts, complete with a wooden barrier around the top to shield those patrolling and defending the town.

DID YOU KNOW?
Football has been played in the courtyard of Stirling Castle for over 500 years. Records show that in April 1497, James IV paid 2s for a bag of 'fut ballis'. The oldest surviving football, believed to date back to 1540, was found behind panelling in the castle.

The Black Boy Well, built in commemoration of those who died of the plague (aka the Black Death) on the site of the old gallows.

6. The Battles for Stirling

The importance of Stirling as a stronghold and a crossing point has been discussed, and so it should not be surprising that several significant battles took place here, particularly during the first Wars of Independence with England, fought between 1296 and 1328. Arguably the most famous of these was the Battle of Stirling Bridge, fought on 11 September 1297. In 1296, after King Balliol refused to support the English in their war against France, Edward I invaded Scotland. The first significant battle, the Battle of Dunbar, was a decisive English victory, with many Scots nobles either killed or taken prisoner. It was seen as a devastating blow for the country, with King Balliol being forced to publicly apologise to Edward, before being stripped of the royal badge on his clothing. The important castles in the Lowlands, including Stirling, surrendered without a fight, and the Stone of Destiny (on which the Scottish kings were crowned) and many important historical documents were taken from Scotland to England. Edward appeared to be firmly in control of Scotland – or so he thought.

John de Warenne, the Earl of Surrey, had been appointed as the Warden of Scotland by the king, but shortly afterwards he left Scotland and returned to England, complaining that the weather was making him ill. This left a power vacuum, and in the north there was a growing uprising that fought back against the English invaders. Before long, while the Lowlands remained under English control, the land from the River Forth northwards, with the exception of Dundee, was under the control of William Wallace and Andrew Murray. John de Warenne was ordered back to Scotland to retake control, and he marched north with an army of around 9,000 men. At Stirling, the wooden bridge that spanned the River Forth remained the key crossing point for an army of any significance, and was the one that John de Warenne would have to use. When he did, he found the army of William Wallace and Andrew Murray waiting on the opposite bank.

DID YOU KNOW?
The Battle of Stirling Bridge led to a permanent change in hand-to-hand warfare. Being relatively poor, most of the Scots soldiers did not have the heavy armour of the English and instead fought with handheld spears. After their victory, partly due to their manoeuvrability when not restricted by armour, polemen became a main part of infantry formations over the following 100 years.

Warenne did not seem to be worried. He was confident that with word of the previous English victories and having a larger army, the Scots would be willing to negotiate a peaceful outcome. After several days there was genuine surprise at their refusal to surrender, so the decision was made to move forward and take the bridge by force. The Scots had set up camp on Abbey Craig, site of the Wallace Monument, giving them a superior viewing point of the bridge and surrounding territory. With many nobles in captivity after the Battle of Dunbar the army lacked the trained fighters that the nobles could have supplied; however, at between 5,000 and 6,000 men it was still a formidable force. The advantage would be their knowledge of the terrain. From their vantage point they could see that a causeway ran through the floodplain of the river, from the base of Abbey Craig to Stirling Bridge. This would restrict the English forces to two horsemen crossing abreast, and once they had done so, due to the way the river meanders, they would find themselves with the river on either side of them with the soft ground of the floodplain between. Wallace estimated it would take several hours for the whole army to cross and the layout of the land would mean that the front runners would have no way to retreat due to the troops behind continuing to cross, pushing them forward.

The English forces moved forward twice, but were recalled. The first time allegedly because Warenne had overslept, and the second time because he believed the Scots were finally ready to do a deal. Two friars were sent to obtain Wallace's surrender, but returned with a note telling the English commanders that they were here to do battle. Warenne finally decided to advance and sought to send cavalry upstream to cover the crossing, a move that was refused by the king's treasurer, who demanded that they get on with it and stop wasting time and money.

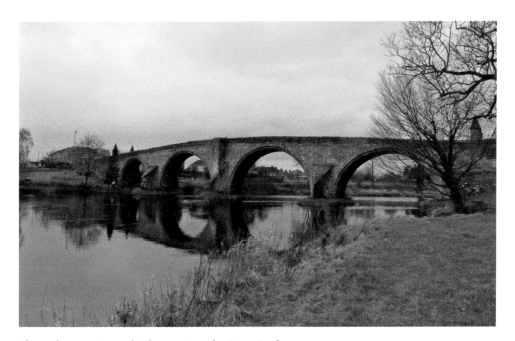

The replacement stone bridge crossing the River Forth.

The entrance onto the replacement bridge over the Forth gives an idea of the narrow crossing faced by the English forces. (© Euan Nelson, cc-by-sa/2.0)

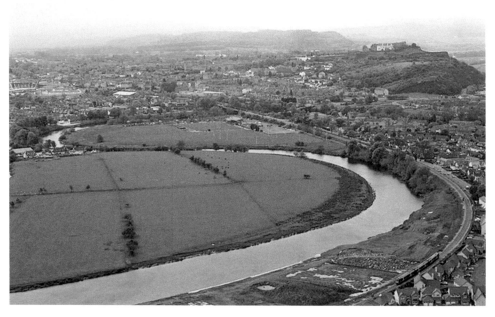

This view over Stirling shows how the river meanders, restricting the area of land available for the English forces to do battle. (© Mike Pennington, cc-by-sa/2.0)

The approximate view William Wallace would have had of Stirling Bridge, which at that time would have been unobstructed. (© Allister Combe,)

In what must have been an agonisingly slow time, Wallace watched while the English crossed, waiting until enough had crossed so that their loss would have a significant impact, yet not too many that they could not be defeated. When just over half the army had crossed, the Scots attacked. Spearmen charged down the Causeway, while others forced their way along the riverbank to secure the bridge, preventing any more of Warenne's army from crossing and cutting off any retreat. With the English on the north side of the river massively outnumbered and the soft land leaving their heavy cavalry virtually useless in attack, most were killed – the only survivors were those who were able to swim back across the river. After destroying the bridge to prevent the Scots from pursuing, the English on the south bank retreated back to Berwick, taking with them all but a small garrison that were left in Stirling Castle, which was retaken by the Scots soon after.

With an estimated 100 cavalry and 5,000 infantry dead, the victory was significant, not only for dealing a significant blow to the English army, but it left the Lowlands back in the control of the Scots and boosted morale throughout the country by showing that despite the previous losses and the English army being larger with heavily armoured horsemen, they were not invincible.

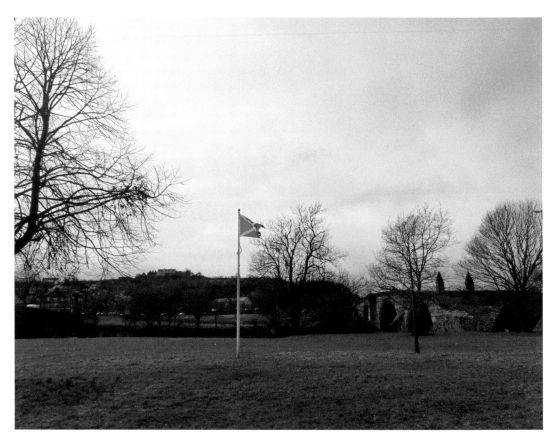

The area where the Battle of Stirling Bridge was fought. Note the position of the castle in the background.

Battle of Stirling Bridge Stone, set in the ground in the shadow of the auld brig of Stirling to commemorate the battle in 1297. (© Robert Murray, cc-by-sa/2.0)

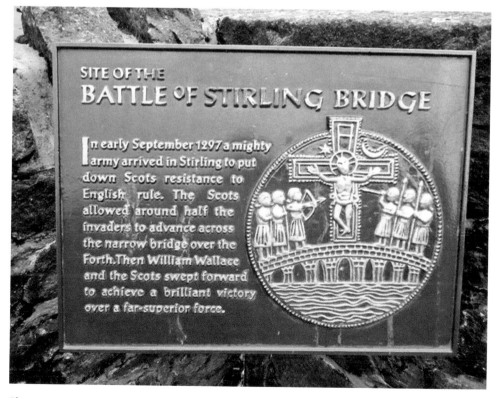

Plaque to commemorate the battle of 1297 on a plinth situated near the north entrance of the auld brig of Stirling. (© Robert Murray, cc-by-sa/2.0)

Memorial stone to Andrew Murray, who led with William Wallace and died from the wounds inflicted during the battle. Sadly the memorial stones are badly weather worn.

In 1304, Stirling would be at the centre of another significant battle. William Wallace had been defeated at the Battle of Falkirk in 1298 and resigned as the Guardian of Scotland, a title that was passed to Robert the Bruce, after which Edward I once again ordered a full-scale invasion of Scotland. After six years the only stronghold remaining in Scots hands was Stirling Castle, and Edward was determined to take it. Armed with twelve fortified, wheeled battering rams known as siege engines, the English attacked in April 1304. They tried everything: bombarding the castle for months with both stone and lead cannon balls (the lead was stripped from nearby church roofs to keep a constant supply), Greek fire (a form of flaming, combustible compound that could be hurled) and even a special mix of gunpowder. In the end, Edward lost patience.

He had his chief engineer, Master James of St George, draw up plans and construct a massive counterweighted catapult, which became known as the Warwolf. Eventually, on 24 July, the castle was surrendered.

There are differing stories about the circumstances. Some reports say that so much material was thrown at the castle that the moat filled, allowing ladders to be set and the walls scaled. Others say that the wall was eventually breached either by a battering ram or a missile thrown at the castle. But most likely is that, after over three months, the men ran out of supplies. Once inside, Edward found that the castle had been held by just thirty men, and perhaps as a sign of his appreciation of their bravery, they were taken prisoner rather than being slain. Their leader, Sir William Oliphant, was sent to the

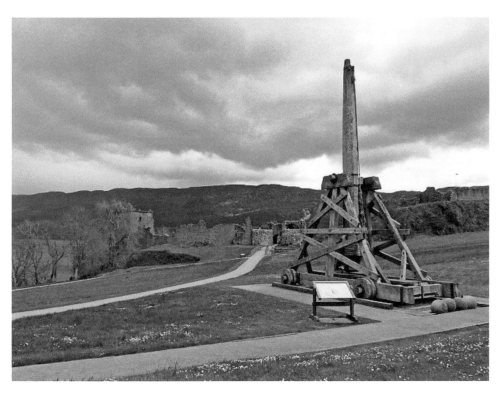

A weighted catapult similar to the one used against Stirling Castle by King Edward. (© Robin Drayton, cc-by-sa/2.0)

Tower of London. The only casualty from within the castle was the Englishman who had previously surrendered it to the Scots, who was executed.

Moving forward to 1314, another battle took place, which could equally be considered the most famous in Scottish history – the Battle of Bannockburn. Robert the Bruce controlled Scotland at this time, with the remaining supporters of King Balliol accepting him as their new ruler; the English king at this point was Edward II. Stirling Castle was held by the English, but with the surrounding area controlled by the Scots it was only going to be a matter of time before they surrendered. With the growing threat, Edward II decided to invade.

The king sent a massive army, estimated to comprise of around 2,000 horsemen and 25,000 infantry from England, Wales and Ireland. Even though it is believed only around half the infantry reached Scotland, it was still the largest army from England to invade Scotland. The Scots army, by comparison, was tiny, comprising of around 6,000. These were mainly infantry and split into three divisions, led by King Robert the Bruce, his brother Edward, and nephew Sir Thomas. The Scots army had operated mainly using guerrilla warfare tactics for several years, and so were well experienced.

As the English moved towards Stirling, they faced the Scottish army just south of the town. Bruce had picked the battle site well: it had areas of marshland and the Bannock Burn (a burn running through the town) to create a natural obstacle to the English,

particularly their horsemen. In addition, a number of small pits had been dug to restrict any charge and a large area of woodland behind would allow easy escape for his army if needed. As the battle commenced, few could have imagined what was to follow. Some of the Scots forces retreated to the woods and were pursued by a division of the English cavalry headed by Sir Henry de Bohun. As they charged, the English knight spotted King Robert and altered course to charge him down. Bruce avoided the attack and as Bohun passed he swung his axe, crushing the Englishman's head. Seeing one of their commanders struck down so early into the battle caused many of the English to lose their nerve; however, they regrouped and, led by Sir Henry Beaumont and Sir Robert Clifford, they sought to outflank the Scots and cut off any escape route.

One of the Scots divisions had been waiting within the woods and they charged the English cavalry, catching them by surprise. Without the protection of archers, and in a confined space, the cavalry found it almost impossible to push their way through the Scots forces, which comprised mainly of spearmen, and they retreated. While most battles of this period would last a matter of hours, the Battle of Bannockburn was about to go into a second day.

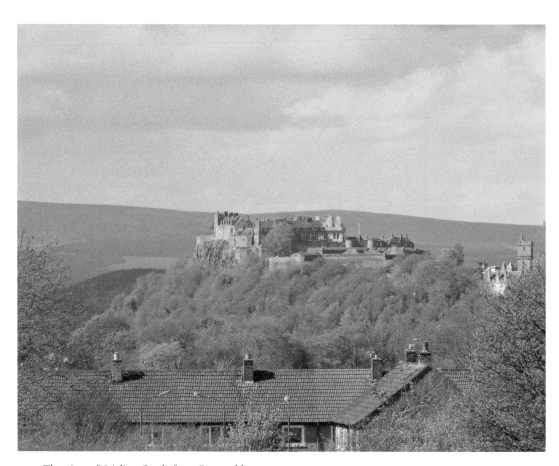

The view of Stirling Castle from Bannockburn.

View of the battlefield at Bannockburn. (© Stanley Howe, cc-by-sa/2.0)

Bannock Burn, located close to the battlefield. This small burn caused considerable problems to the heavy cavalry of the English army. (© Robert Murray, cc-by-sa/2.0)

Throughout the night the English moved to the opposite side of the Bannock Burn to set up camp. The English were demoralised by the outcome of the first day of the battle and feared what fate may be waiting them as it continued. Meanwhile, the English force commanders intended to draw Bruce and his army out into an open battlefield.

A crucial part in Bruce's victory was the defection of Sir Alexander Seton. Sir Alexander was a Scottish knight and Governor of Berwick, and had been fighting for the English. He brought with him the news of the position of the English army, and the overall deflated mood of the soldiers, urging Bruce to attack rather than wait.

The following morning, the English were surprised to see the Scots advance on them from the woods. Keen to keep up morale on his own side, and knowing that tradition had it that you should have religious protection around you, Bruce had given a speech invoking the power of St Andrew and the abbot of Arbroath carried relics of St Columba with the army. The abbot of Inchaffrey also accompanied the army and gave blessings as the Scots knelt and prayed. Seeing this, Edward thought they were asking for mercy, but his advisors soon corrected him, pointing out they were making their peace with God and that none would flee the fight.

As the battle commenced, the Earl of Gloucester, who led a small initial attack, was surrounded and slain. The English archers tried to give cover but the Scots quickly advanced, pushing them back and leaving the English knights stuck between the Scots to the front and their own army to the rear. Some of the Welsh long bowmen tried to outflank the Scots and provide protection for the knights, but when their arrows started striking them instead in the confined space, they were ordered to cease. Further attempts by the bowmen to get into a position to attack resulted in them being cut down by the Scots cavalry.

After the defeat of the English at Bannockburn, Robert turned his attentions to Stirling Castle once more, which was being held by Sir Philip Mowbray and Scottish nobles who had opposed Robert and sided with Edward. Mowbray had however previously agreed that if the English forces hadn't arrived by 24 June, he would relinquish control of the castle. While they had arrived, they had been soundly defeated. Mowbray honoured his agreement, not only handing the castle over to Bruce, but also swapping his allegiance to him. As Bruce had done with virtually every stronghold he took, he ordered that Stirling Castle be destroyed, to prevent it ever falling into English hands again.

DID YOU KNOW?
It is rumoured that the Knights Templar may have helped Robert the Bruce in his victory at Bannockburn. With arrest warrants for the knights in place across much of Europe from the year 1307, many fled to Scotland. Not long after Bruce began to enjoy significant battle victories, leading to the suggestion that it was these experienced warriors who were assisting.

7. Stirling and the Reformation

Scotland had been a Catholic country since its earliest days, with towns like St Andrews being considered to be the country's equivalent to Rome. As the Protestant Reformation swept through mainland Europe and England, it was inevitable it would come knocking on Scotland's door, and the result was years of death and destruction. Before examining its effect on Stirling, the religious position of the country should be briefly explained to put things into context.

The religious unrest first came to Scotland in the sixteenth century, when Protestant preachers were travelling across Europe teaching the new ways, and countries began to convert. Under the Protestant religion the Church yielded less authority in the running of the country's affairs. It is easy to see why this was perhaps attractive to the people, having lived under the rule of the Church for centuries, yet it is equally easy to see why the Catholic Church fought against losing their power. In Scotland, the decision was made that any attempts to preach the Protestant faith would be dealt with swiftly and decisively to show the people that it was not in their interest to consider converting. The first to find out just how far the authorities were prepared to go was a young man named Patrick Hamilton. He had left Scotland to travel Europe before returning to Scotland to study at St Andrews University. During his travels he had heard the teachings of a reformer named Martin Luther and, perhaps rather naively, he seems to have been enthusiastic to openly talk about and go on to preach what he had learned at the home of the Scottish Church. Needless to say, Dr James Beaton, the Archbishop of St Andrews saw things quite differently, and considered this to be nothing but defiance of the Church and country. He ordered that Hamilton be captured and brought to him, but Hamilton was tipped off in advance and managed to flee back to Europe.

Perhaps as a sign of his faith, he soon returned to Scotland to resume both his studies and his preaching in the town. On the face of it, things seemed to have changed and he was left to go about his day-to-day life unchallenged. However, Beaton had been luring Hamilton into a false sense of security all along. After some time, an invite was issued to Hamilton to meet the archbishop at his castle to discuss what he had learned during his time in Europe. Whether Hamilton had any suspicions about this is not known, but if he did he was correct as he was arrested as soon as he entered the castle gates. A show trial followed, and it was clear the Archbishop Beaton wished to make an example of Patrick Hamilton to send the message out to those who had listened to him in the town.

On 29 February 1528, Hamilton was taken from his confinement at St Andrews Castle and walked to Market Street where, at the front of St Salvator's Chapel, he was chained to a stake on top of a small pile of wood. What followed was probably even more horrific than had been intended. Having refused to repent, which would have allowed him to be strangled before being burned, the fire was lit. A small amount of gunpowder set in the

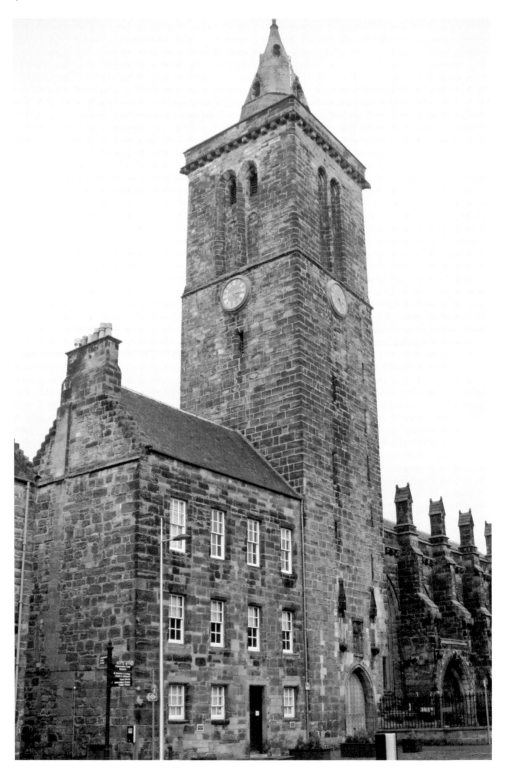

St Salvator's Chapel in St Andrews, outside which Patrick Hamilton was burned to death.

wood pile by his supporters exploded, causing significant burning to Hamilton's side while blowing out the flames below him. The fire was relit, but would not take. After several attempts and replacing what was found to have been wet wood with suitably dry wood to burn, Hamilton finally succumbed to the fire – six hours after his ordeal had started.

If Beaton had planned to send out a message through the execution of Patrick Hamilton, he did, although not the message he wanted. Many of the students who had witnessed the horror were friends of Hamilton and had heard him talking of the peace of the Protestant faith before seeing the cruelty of the archbishop. Even Beaton's own advisors warned him that if there were to be any more executions they should be burned out of public sight as the smoke of Patrick Hamilton had infected as many as it blew upon, meaning most who had witnessed the burning were now supporters of Patrick Hamilton's cause, whether they had been before or not. This sound advice was ignored.

Henry Forrest was next to meet his fate. His crime was being in possession of the New Testament, which resulted in him being burned at the stake on the high land above St Andrews Harbour to ensure the flames could be seen as far away as Dundee. Much to the frustration of the Church, the Protestant preachers grew in number and more

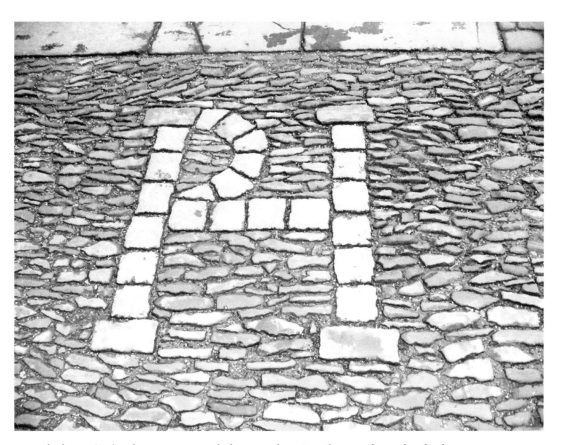

The letters 'PH' in the pavement mark the spot where Hamilton was burned to death.

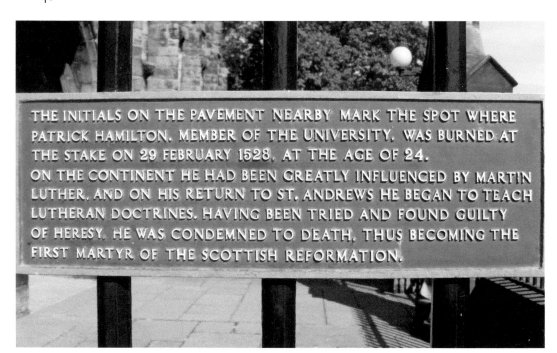

THE INITIALS ON THE PAVEMENT NEARBY MARK THE SPOT WHERE PATRICK HAMILTON, MEMBER OF THE UNIVERSITY, WAS BURNED AT THE STAKE ON 29 FEBRUARY 1528, AT THE AGE OF 24.
ON THE CONTINENT HE HAD BEEN GREATLY INFLUENCED BY MARTIN LUTHER, AND ON HIS RETURN TO ST. ANDREWS HE BEGAN TO TEACH LUTHERAN DOCTRINES. HAVING BEEN TRIED AND FOUND GUILTY OF HERESY, HE WAS CONDEMNED TO DEATH, THUS BECOMING THE FIRST MARTYR OF THE SCOTTISH REFORMATION.

A memorial plaque telling of Hamilton's suffering.

It is said when Patrick Hamilton finally died in the flames, his face was etched into the stone of the tower as a mark of his agony.

people began to turn to them. In 1539, Cardinal David Beaton succeeded his uncle as Archbishop of St Andrews and launched a new campaign to crush the Protestants, which would lead many to believe he was in fact in league with the Devil. Cardinal Beaton had the advantage of also being one of the most trusted advisors of James V, meaning he had power both within the Church and monarchy, so few would dare oppose him. When King James died in 1542, leaving his infant daughter Mary as the heir, Beaton produced falsified documents to try to take control of the country as her regent, but failed. Mary was taken to Stirling and crowned at Stirling Castle on 9 September 1543, aged just nine months, and went on to stay within the safety of the castle under the care of her guardian, Lord Erskine, for several years. Cardinal Beaton meanwhile turned his attention, and frustrations, back to the Protestant preachers. His actions in 1546 would be the turning point for the Reformation.

DID YOU KNOW?
The Church of the Holy Rude is the only church outside of London to have hosted the coronation of a monarch.

Under the rule of Henry VIII England had already converted to the Protestant faith and a period known as the 'Rough Wooing' had commenced. Henry wanted an arrangement for his son, Edward, to be married to Queen Mary when they were old enough, which was agreed under the Treaty of Greenwich in August 1543. The treaty was thrown out by the Scottish Parliament, however, as despite it including that Scotland would retain its own laws, it would mean placing Scotland's Catholic Queen into matrimony with a Protestant king. A later proposal for Mary to be betrothed to the son of Henry II of France – a Catholic country – was the favoured option. In the interim, the English had started to launch a series of attacks on Scotland to try to persuade those in charge to honour the Treaty of Greenwich.

During this time a preacher named George Wishart had risen to prominence after studying the Protestant beliefs in England. Having tried, and failed, to discredit him and trying to use the example of the Rough Wooing as evidence against the Protestant faith, Beaton eventually had Wishart arrested and brought to St Andrews Castle in 1546. Just as young Patrick Hamilton had all those years before, Wishart faced a mock trial in St Andrews Cathedral before being found guilty of heresy and taken to a burning point opposite the castle. With a massive crowed gathered, and knowing that many may be supporters of Wishart, over 100 armed guards escorted him and surrounded the execution point. While Wishart was burned alive (some early depictions showing him being suspended by metal chains above the flames) Cardinal Beaton watched from the luxury of his quarters in the castle, in full view of the crowd. He underestimated the changing attitude among the townsfolk. It is widely reported that even the executioner begged Wishart for forgiveness prior to lighting the fire. Just weeks later, however, Beaton found out just how strong support for George Wishart was.

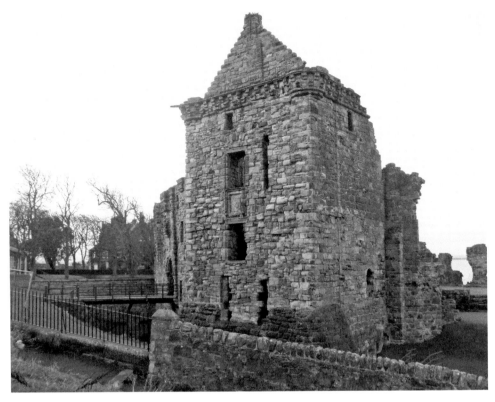

St Andrews Castle, from which Cardinal Beaton watched George Wishart die.

The letters 'GW' in the road mark the spot where George Wishart was burned to death.

While workers were being allowed into the castle to reinforce the defences, ten men silently joined the queue. Once they made it within the castle walls, they forced everyone out. This was a period of high tension, with everyone on edge waiting for an attack, and so when one seemingly came, many fled pushing the guards out with them. Once the gates were closed, the ten men, supporters of George Wishart, were alone in the castle with Cardinal Beaton, who had locked himself in his private apartment. Under the threat of being burned out, Beaton unlocked the door and was stabbed several times before his naked body was hung from the very window he had watched Wishart burn from.

With the head of the Catholic Church dead and his palace in the hands of Protestant supporters, the country faced a crisis. Those inside the castle were holding out for the invading English forces to arrive, knowing that their actions would be considered favourable by Henry VIII. And their hopes were not misguided, as in September 1547 the Scots had suffered a significant defeat against the English at the Battle of Pinkie Cleugh. With the English forces advancing on Edinburgh, then Stirling, Queen Mary was taken to Inchmahome Priory. However, the French navy were also approaching, as they sought to agree a treaty for Queen Mary to go to France. Unfortunately for those holding St Andrews Castle, the French arrived first, bombarding the castle from the sea and ending the year-long siege. In 1548, in return for military aid, the Scottish Parliament agreed a marriage treaty with the French, and Queen Mary was taken to France.

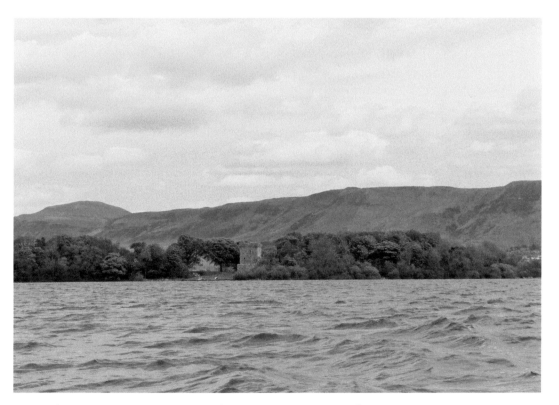

Loch Leven Castle, one of several used to imprison Mary, Queen of Scots.

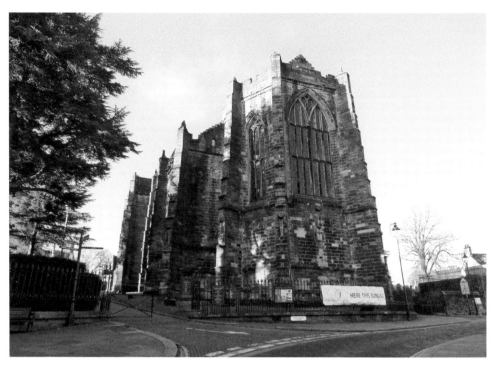

The Church of the Holy Rude, Stirling.

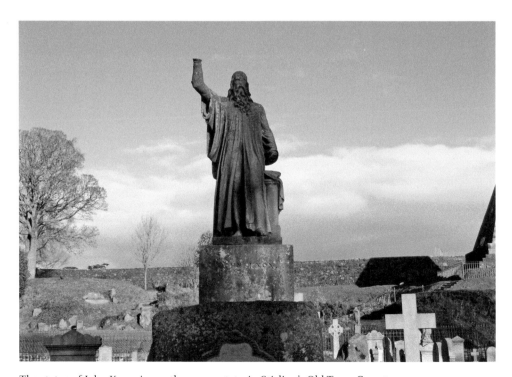

The statue of John Knox, in a rather sorry state, in Stirling's Old Town Cemetery.

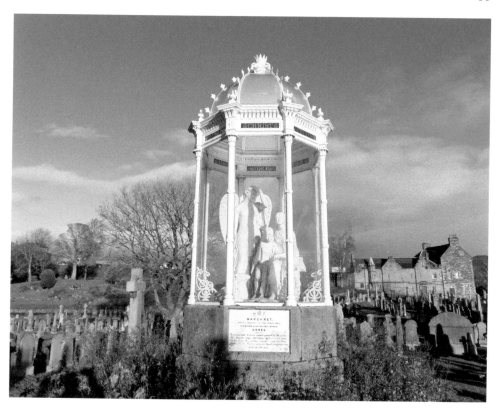

The Martyrs' Monument in Stirling Old Town Jail, which depicts the sad image of an angel watching over two young girls, Margaret and Agnes Wilson, who were arrested for holding the Protestant faith. Margaret was put to death by being tied to a stake below low tide and drowned.

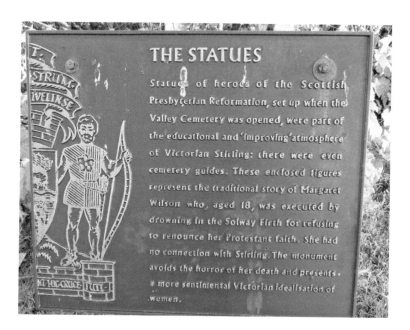

The memorial plaque for the Martyrs' Monument.

The reformers surrendered to the French on the belief that they would be treated more favourably by them than the Scottish authorities. They were sent to the French galleys, where they served several years working as galley slaves before being released. Within the group was a man named John Knox, a former bodyguard of George Wishart. He travelled to England, where he had been offered a safe haven – it was believed the English Parliament had in fact aided his release. In 1559, John Knox returned to Scotland. With Queen Mary still in France the country remained under the rule of her regent, who attempted to draw Knox to Stirling. He refused her invitation, however, knowing her intention was to have him charged as an outlaw. When the regent fell seriously ill, Knox stepped in and started to persuade the Scottish nobles that they should convert to the Protestant faith. He would go on to deliver a number of powerful sermons across Scotland, each resulting in the of the destruction of the church and any surrounding Catholic establishments by fired-up reformers.

When Queen Mary returned in 1561 after the death of her French husband, the Reformation was well underway and despite their differences, which often led to heated arguments in private meetings, Queen Mary forged an uneasy truce with John Knox, who was by then considered head of the Protestant Church, and they worked together on matters in the best interest of the country where they could. In 1565,

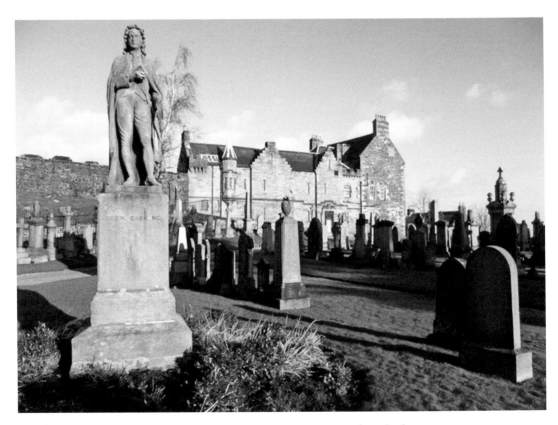

Ebenezer Erskine statue, Old Town Cemetery. (© Kim Traynor, cc-by-sa/2.0)

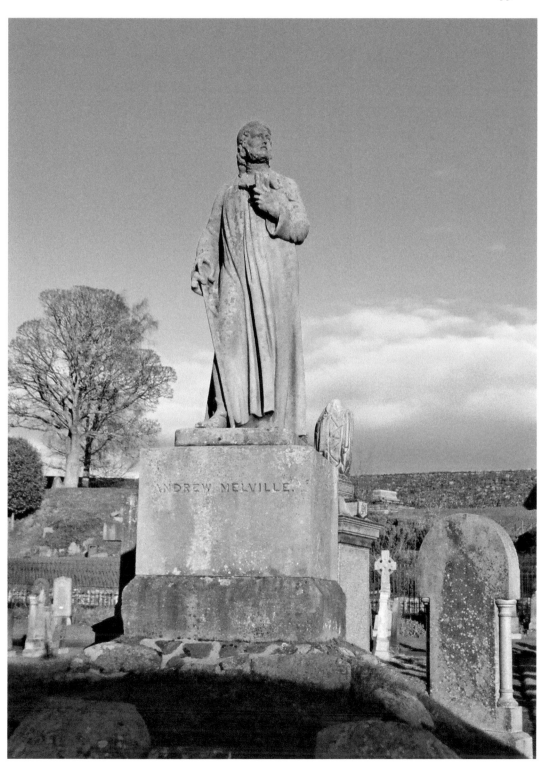

Andrew Melville statue, Old Town Cemetery.

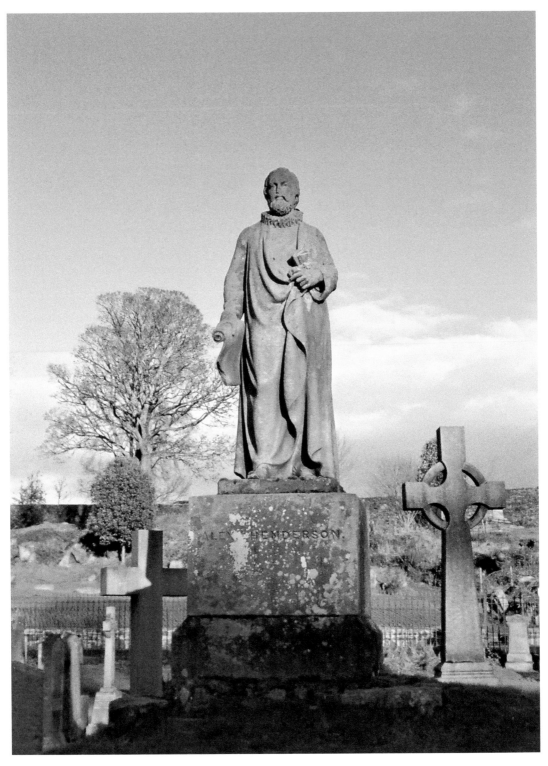

Alexander Henderson statue, Old Town Cemetery.

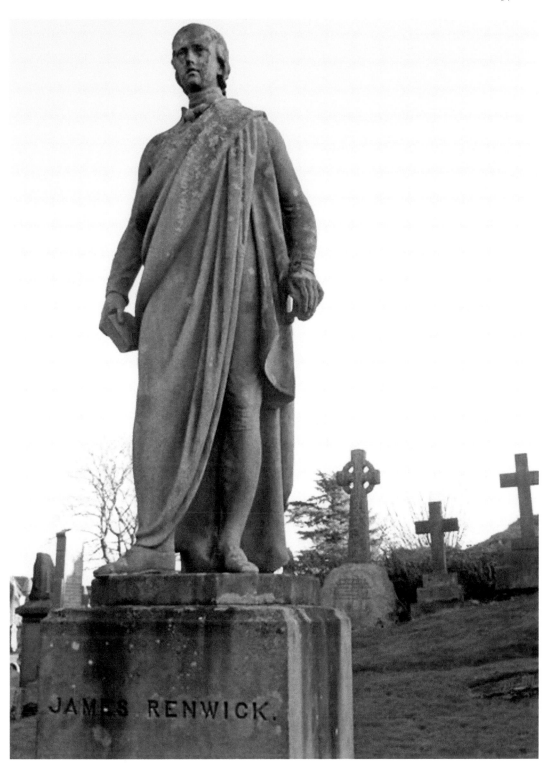

James Renwick statue, Old Town Cemetery. (© Kim Traynor, cc-by-sa/2.0)

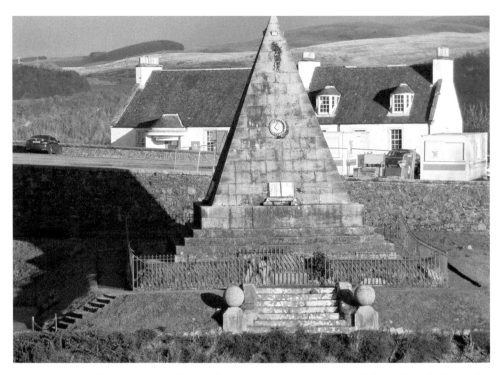

The Star Pyramid, commissioned by William Drummond in 1863, is dedicated to all those who suffered martyrdom in the Reformation.

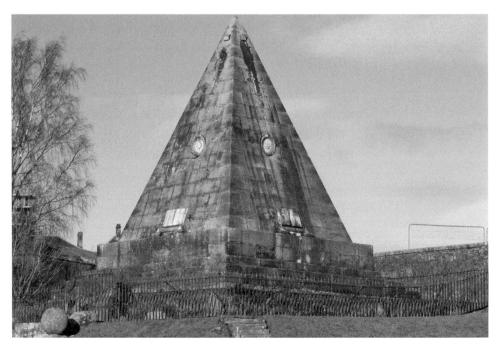

The Star Pyramid.

Mars Wark, a mansion built from stone from Cambuskenneth Abbey.

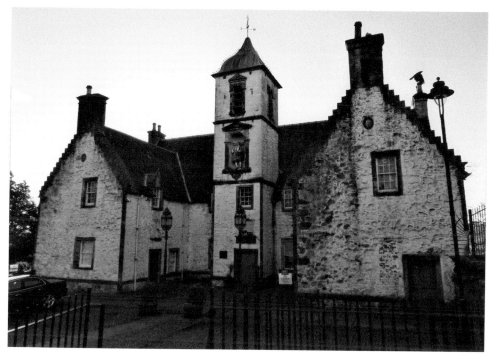

Cowane's Hospital was established in 1637 to provide accommodation for the poor.

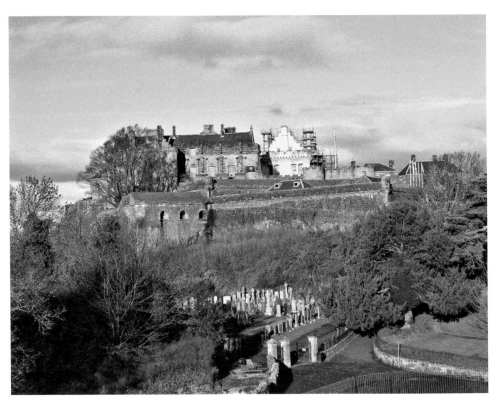

A side view of Stirling Castle, where Mary, Queen of Scots spent much of the infant life.

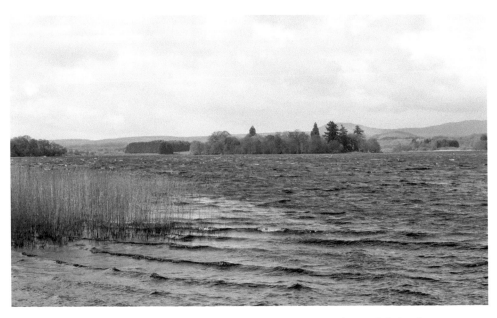

Inchmahome Abbey sits on an island in the Lake of Menteith. A castle stands behind on a separate island. (© Richard Sutcliffe, cc-by-sa/2.0)

the queen married her cousin, Lord Darnley, and in June 1566 she gave birth to their son, James. Much to the dismay of the Protestants, Mary had him baptised into the Catholic faith at Stirling Castle. The following year Lord Darnley died under mysterious circumstances, with it widely being believed that Mary had some involvement in his murder. She was arrested and held at Loch Leven Castle, while James was kept in the safety of Stirling Castle, where Mary last visited him between 21 and 23 April 1567. On 29 July, James was anointed King of Scots in the Church of the Holy Rude, Stirling's second oldest building. John Knox preached at his coronation sermon and called for the queen to be executed, although on this occasion the authorities decided to go against him.

In 1559, the town council of Stirling had made the choice to change their support for Catholicism and to move towards the Protestant faith, which reduced the extent of destruction it saw. The Church of the Holy Rude was undergoing a third stage of reconstruction after being destroyed in a fire in 1405. The Reformation saw the end of this work, which would have added a large central tower and heightened the nave to match the choir, leaving the church with the unusual appearance it has today. There are several statues commemorating the reformers in the Old Town Cemetery.

The town did not go unscathed, however, with the preaching of John Knox leading to the destruction of the monasteries of both the Black Friars and the Grey Friars. Cambuskenneth Abbey was abandoned too, leaving it to be used as a quarry for stone for the construction of several of the fine buildings we see around Stirling today, including Mar's Wark, a mansion house close to the castle.

In 2014, while work was being carried out on a site close to Stirling railway station, a remarkable discovery was made. Archaeologists were called in and the remains of the Black Friars Monastery were uncovered, the location of which had long been lost to history. A large-scale excavation was carried out, revealing the true extent of what must have once been an imposing building, during which a human skeleton was discovered. Due to the position in which the body had been buried, along with a bronze buckle and some textiles found with the bones, it has been possible to identify it as the remains of one of the priests, believed to be a man aged between twenty and thirty-five who died sometime between 1271 and 1320.

8. Oliver Cromwell in Stirling

Oliver Cromwell is without a doubt one of the most famous and vilified people in British history. When his name is mentioned thoughts of war and destruction come to many people's minds, and that is certainly true, yet some scholars argue that he was in fact a key figure in bringing peace to the country. Areas that fell under his control saw considerable investment in the rebuilding of the infrastructure, including defences. Before discussing his impact on Stirling it is important to set out the background surrounding his rise to power.

In 1603, Elizabeth I of England died unmarried and with no children. With no direct heir, the crown was passed to her closest living relative – her cousin James, who just so happened to be James VI of Scotland. After centuries of war to try to and unify the two kingdoms it happened through the peaceful means of family connections, with James becoming James I of England in addition to being the monarch of Scotland. As the kingdoms of England and Ireland had already been unified, King James, in reality, became the leader of the three nations.

Any hopes that the unification of the crown would continue peacefully were soon dashed. While the crowns may have been joined, the two nations were still very much independent, with separate parliaments and operational structures. The nobles and authorities of England also objected to the head of the smaller of the two kingdoms taking joint control. The biggest obstacle he faced, however, was the differing religious practices. In order to try to bring his kingdoms together he was going to have to try and find either middle ground or persuade one nation to adopt the other's belief system.

King James faced opposition from the start, with several attempts being made on his life, the best known of which being the Gunpowder Plot, which is still remembered every year on 5 November. The English Parliament also made things very difficult for James, opposing many of his attempts to bring consistency between his kingdoms. He did still manage to make progress in some areas, particularly foreign affairs, yet overall his reign as the joint monarch was a frustrating time.

In 1625, King James died, and his son Charles I succeeded him to the become the joint monarch. Charles realised the importance of conformity in the religious practices of both nations. The Church, particularly in Scotland, still yielded great power, and he knew if he could resolve that issue the other areas of dispute would become easier to find solutions to. However, this would bring him into direct conflict with both the Scottish Church and English Parliament, both of which resisted any attempts to make changes. In 1629, seeing no way forward, he took the unusual step to dissolve the English Parliament, allowing him to rule without their input. Unfortunately, this also weakened his position, as without Parliament to pass legislation he was somewhat limited in what he could do.

A statue of Cromwell at Wythenshawe Park in Manchester. (© David Dixon, cc-by-sa/2.0)

The remains of a massive citadel built by Cromwell in Ayr as part of his improvements to the town's defences. (© Thomas Nugent, cc-by-sa/2.0)

Cromwell had a citadel constructed in Inverness, although all that remains is a clock tower, which marks the area.

In Scotland, the Covenanters, a Presbyterian religious movement, was gaining strength and support and strongly opposed the king's attempts to interfere with the religious practices of the country.

Realising the threat, King Charles sought to crush the Covenanter movement, yet there was little to no appetite among the English nobles – who controlled most of the armies – to provide soldiers to do battle in Scotland over an issue that they did not consider to affect them. With no Parliament to approve and pay for military action, the

king was left with no option but to march north with the small army he was able to put together and, in February 1639, he launched a campaign against the Covenanters, in what would become known as the First Bishops' War. It was a short-lived operation, with the king withdrawing his military and signing the Treaty of Berwick, which put in place a temporary truce between the two sides.

DID YOU KNOW?
When Cromwell first marched on Stirling in 1650 along the old Roman road, it was found to be in such poor condition that he had to send the heavy artillery he had taken to lay siege to the castle back to Edinburgh. If he had managed to take it to Stirling, the outcome may have been very different.

Humiliated and no doubt enraged, Charles returned to London and reformed the English Parliament, with one of the first requests submitted being for funding to launch a full-scale attack on the Covenanters. Unwilling to forget the monarch's earlier actions, the request was swiftly refused. He was at a stalemate: he could not put together a sufficient army to launch a further attack without the backing of the Parliament, yet Parliament had no interest in funding a religious war in Scotland, preferring to see any money being spent within England. Seeing the king in such a weakened position, the Covenanters decided to bring the fight to him, and marched across the border into England, seizing Newcastle and forcing Charles to admit defeat.

This was the final straw for the English Parliament. With the nobles being deeply unhappy at the inefficient king, who only seemed interested in what they deemed to be a problem in Scotland (still an independent country), they decided to take action. Realising that the Scottish nobles were also despondent at the king's inability to defeat what they considered to be a small religious group, along with his attempts to better align Scotland with England, the English reached out to the Scots to seek help in dealing with their common problem. The Scots agreed, on the basis that the religious matter was to be settled with the English taking no more interest in the religion of Scotland. In 1646, a combined English and Scottish army challenged Charles and, with very few supporters, he surrendered to the Scottish commanders. If he did this thinking that they would be more lenient in their justice he was wrong.

After protracted negotiations, he was handed over to the English in return for a sizeable payment, and the Scots withdrew north of the border. The king was then executed the following year.

During this time, with a Royalist threat remaining, the English Parliament had been putting together a new fighting force. Differing from traditional garrisons, it was made up from regiments from different regions, allowing it to be put together as a single army that could go to war anywhere in the country with full-time soldiers, leading it to be known as the New Model Army.

Charles escaped his English captives and fled to the Isle of Wight, where he was once again imprisoned, prompting the Royalist forces still loyal to him to rise again resulting in a second civil war in England. The uprising was quickly defeated by the New Model Army and King Charles returned to trying to negotiate his way to safety. With several of the military commanders, including Oliver Cromwell, objecting to further discussions, Charles was sent to trial on the charge of treason and beheaded in 1649. The leaders of Scotland deemed that the crown should pass to Charles's son, also named Charles.

In the meantime, having defeated the Royalist forces in England, the English Parliament declared England to be a Republic, with Cromwell as Lord Protector of the Commonwealth. While he initially reached out to the Scottish Parliament the acceptance of Charles as their monarch was, in his eyes, an act of defiance and with the Scottish Covenanter forces joining the Royalist army in both Scotland and England (as they hoped that would influence Charles to impose their Presbyterian religious beliefs in England and Wales), Cromwell made the decision to seize control by force.

Cromwell's campaign for Scotland started in July 1650, and after an unconvincing start, he was victorious at the Battle of Dunbar in September 1650, and his momentum built. The Scots forces were led by Sir David Lesley, Lord Newark. His forces seemed, on all accounts, to have the upper hand: he vastly outnumbered Cromwell in troop numbers and was well organised. However, a concentrated attack by Cromwell resulted in disrupting the formation of the Scots army, leaving between 800 and 3,000 Scots dead, and up to 10,000 taken prisoner. Cromwell advanced to Edinburgh, taking control of the city but not the castle. Meanwhile, Lord Newark had escaped to Stirling, where he regathered his troops and called upon the Highland chiefs. As had happened in Scotland since its early origins, the clans were prepared to put aside any differences and come together against the common enemy. Even nobles who had not been supporters of Charles began to support the Royalist cause, as it was deemed a better option than succumbing to Cromwell's rule.

Cromwell knew the importance of Stirling. The only road suitable to move military forces from southern Scotland to the north was the one that crossed Stirling Bridge. It was the only thing that prevented him from marching north to face the Highland forces before the alliances being formed created a force potentially too large for him to defeat and to seize the rich resources of the central belt, cutting off the supplies to the north. His difficulty was his army remained relatively small and was insufficient to lay siege to Edinburgh Castle, which held a massive armoury and was well stocked with supplies, allowing those inside to hold out for a considerable time, a commodity he simply did not have. Yet it was also vital for him to keep control of the town of Edinburgh and the port of Leith, and so for him to advance to Stirling he would still have to leave enough of his troops in Edinburgh to prevent those in the castle retaking the town. He therefore called upon the commanders of the garrisons remaining at the border to send reinforcements, although only around 2,500 men were sent. This was deemed enough by Cromwell, who, rather than wait for more to arrive, marched towards Stirling on 14 September 1650, leaving three regiments to protect Edinburgh.

The New Model Army, under Cromwell's command, advanced on Stirling through Linlithgow and Falkirk, then across Bannockburn battlefield. When they were within

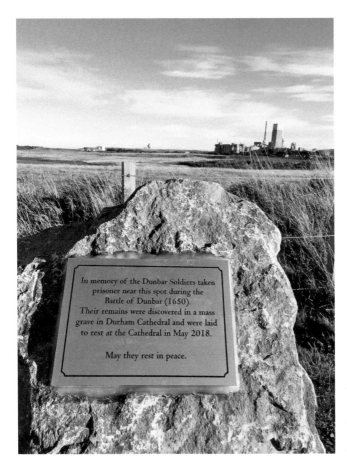

In memory of the Dunbar Soldiers taken
prisoner near this spot during the
Battle of Dunbar (1650).
Their remains were discovered in a mass
grave in Durham Cathedral and were laid
to rest at the Cathedral in May 2018.

May they rest in peace.

'In Memory of the Dunbar
Soldiers taken Prisoner
at the Battle of Dunbar
(1650).' (© Jennifer Petrie,
cc-by-sa/2.0)

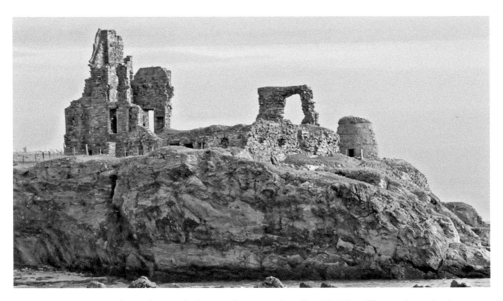

The remains of Newark Castle in Fife, home of Sir David Leslie. (© John Allan, cc-by-sa/2.0)

James Guthrie statue in the Old Town Cemetery. Guthrie was the minister of Stirling and one of the Kirk's commissioners summoned to Glasgow in 1651 by Cromwell, who famously described him as 'the short little man who could not bow'. (© Kim Traynor, cc-by-sa/2.0)

1 mile of the town, battle plans were drawn up, with ladders gathered to prepare for a planned attack on the afternoon of 17 September; yet before onslaught commenced, Cromwell had a change of mind. Having left with only seven days of supplies, the success of any invasion would have to be swift. Yet the defences of Stirling were strong and very well defended. Cromwell also had become aware of just how far he was from his strongholds, and considered that even if his attack was successful, he would be unable to hold Stirling. Instead he ordered his army to retreat to Linlithgow, where they set about fortifying the town to create an outpost from which he could launch a later attack on Stirling. With winter approaching, he left Linlithgow under the guard of Colonel Sanderson and Major Mitchell, and returned to Edinburgh.

Cromwell spent his time increasing the defences of the areas he controlled, while expanding his territory where he could, and continuing negotiations to persuade the Scots Royalists to switch sides. All the time, however, he was planning his next moves. He had miners try to undermine Edinburgh Castle, but his focus remained firmly on Stirling. With the lands to the north of the Forth still under the control of the Royalists, Prince Charles had arrived in Scotland and built support. He was crowned Charles II on 1 January 1651 and took personal control of the army, with Sir Leslie

The island of Inchgarvie, which is now spanned by the Forth Railway Bridge. (© Kim Traynor, cc-by-sa/2.0)

being rewarded for his loyalty by being made second in command. Leslie wasted no time and started to strengthen Stirling's defences and pushing south to establish his own outposts.

On 4 February, Cromwell went against his better judgement and the advice of others and again sought to launch an attack on Stirling. Despite the terrible weather, he advanced his troops. By 7 February, however, with his men falling ill, he retreated to Linlithgow and then Edinburgh, where he fell seriously ill himself from the effects of exposure. While he recovered reinforcements arrived from London and, knowing both how well Stirling was defended and that the deteriorating roads approaching it would make it ever more difficult to take the town, his attentions turned to other methods. On 27 March, four warships set sail from Leith Port, first taking the Royalist-held island of Inchgarvie, approximately halfway across the Forth, before sailing up the river and taking Blackness Castle. By April, Cromwell was able to take command once again, and was determined to take Stirling once and for all. He launched a number of moves over the next few months, including sending ships to attack the port of Burntisland in Fife and sending troops to Glasgow, passing in view of Stirling, all in an attempt to lure Leslie from Stirling into a field battle, but Leslie would not be drawn from Stirling. Cromwell in meantime fell ill twice more, still suffering the effects of his February illness. Fearing for his health, he decided to make a risky move that would prove to be decisive.

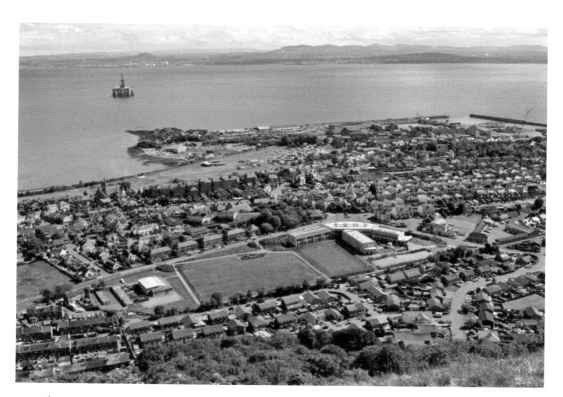

The town of Burntisland in Fife, where Cromwell launched his first attack north of the River Forth. (© Robert Struthers, cc-by-sa/2.0)

A number of specially designed flat-bottomed boats were constructed to transport large numbers of troops across the Forth, and on 17 July 1651 the 1,600 troops successfully crossed. Over the following two days a further 2,500 men made the crossing. Cromwell's intention was to cut the supply lines of both provisions and reinforcements from Fife and Perth to Stirling, forcing Leslie to surrender. Realising the risk, the Royalist forces attacked but were ultimately defeated. Cromwell now had control of the lands to both the north and south of the River Forth, allowing him to use larger ships to transport the bulk of his army over to Fife, where they attacked the Royalist outposts. Cromwell then marched to Perth, the main Royalist base, which surrendered to him on 2 August.

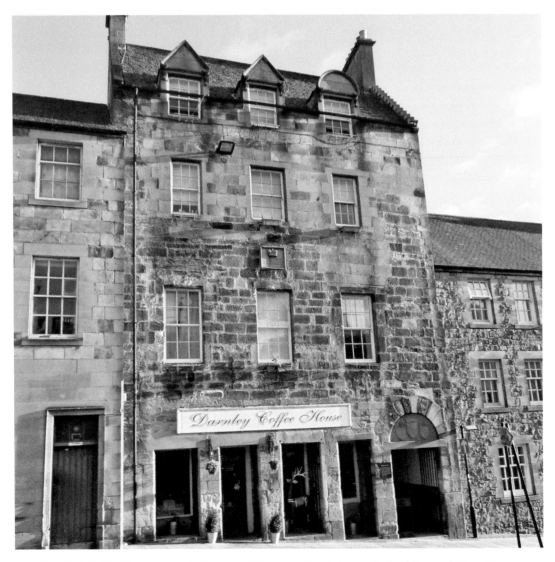

Darnley's Coffee House, named after a possible connection between the building and Mary, Queen of Scots' husband, Lord Darnley. This was the location where Stirling was surrendered to Cromwell.

While this was a crushing blow to the Royalist campaign, Charles saw an opportunity. He was in Stirling and with Cromwell and the bulk of his forces north of the Forth, the road to England lay relatively unprotected. Against the advice of Leslie, he marched south into England. Cromwell, however, had been well aware of this possible eventuality and had prepared for it. He had left 6,000 men and a massive amount of artillery with one of his most trusted men, General Monck, while he pursued the king's army. On 3 August, with an army of between 5,000 and 6,000 troops, General Monck advanced on Stirling and laid siege to the castle. With no supplies and without the military expertise of Sir Leslie, the governor of Stirling Castle surrendered on 14 August 1651, placing the castle, the regalia and the records of Scotland under the control of Cromwell.

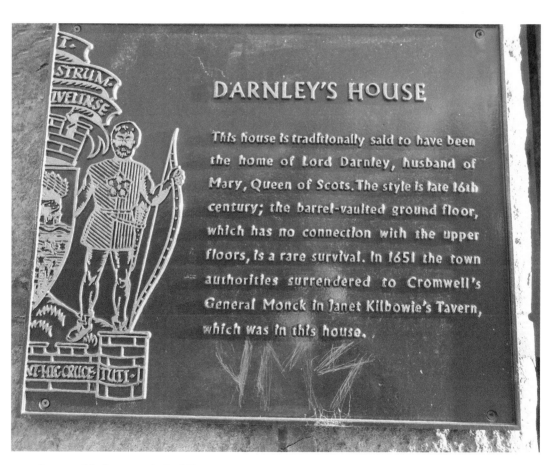

A memorial plaque on the building.

9. The Stirling Witch Trials

It is very easy to look back on the period of the witch trials and the barbaric treatment of people – predominantly women, but also men and children – on the seemingly ridiculous belief of magic with some disbelief. However, to really appreciate the situation we must remember these were very superstitious times and it was not only the Church, which yielded great authority in the country, but also the monarchy who were warning of the great dangers Satan and his worshipers presented to the communities for us to understand the very real fear people of the time had. The belief of magic, particularly dark magic, was nothing new. It had existed for centuries, back to the times of the Druids. There had been accusations and trials for witchcraft before, but it was the Witchcraft Act of 1563 that would start a truly devastating time in the country's history.

The Witchcraft Act was introduced by Mary, Queen of Scots. At the time of her reign the country was in turmoil. The Protestant Reformation had firmly taken grip, with Catholic control being lost and religious establishments being destroyed. As a Catholic, the queen had to make an uneasy truce with the Protestant leaders. The Protestant religion brought a new level of optimism among women who were, albeit slightly, less restricted than they had been under the Catholic Church. In addition, at Queen Mary's time the remnants of the ancient ways still existed, with herbalists known as 'wise women' still following the Celtic beliefs, including the preparation of cures for various ailments. Whether the Witchcraft Act was a result of genuine belief, and fear, of witchcraft or an attempt to crush the old traditions and try to keep women suppressed, is debatable, yet it was effective in both.

The effect of the Witchcraft Act was not immediate, and Queen Mary did not live to witness the true consequence of her ruling, as the trials were few and far between. Events surrounding the marriage of her son James VI and I would lead to the first large witch trial, triggering years of suffering for anyone who did not 'fit in'. King James was set to marry Anne of Denmark in 1589, with a proxy wedding (meaning neither parties were actually present) taking place in Copenhagen. After the wedding, Queen Anne set sail with a fleet of ships to Scotland, where she would join her new husband; however sudden and violent storms forced the ships back, causing them to seek shelter in Norway. Rather than wait for a further attempt for his bride to reach Scotland, James set sail to Norway himself, and in November 1589 they formally married in person at the Bishop's Palace in Oslo. After the wedding, they went back to Denmark on a tour of Queen Anne's native country. Denmark at that time in the grips of a witch frenzy. Most mainland European countries had a deeper belief and fear of witchcraft, based on the writings contained within a book titled the *Malleus Maleficarum* (Hammer of Witches). Written in 1486 by Jacob Kramer and Jacob Sprenger, and first published in Germany in 1487, *Malleus Maleficarum* was nothing short of a guidebook supporting the case for the existence of witchcraft and giving instructions on how to find, interrogate and ultimately destroy a witch.

DID YOU KNOW?
Witch trials were expensive, and where possible the family were expected to pay the bill. An invoice from a case held in Kirkcaldy is available in multiple publications as follows:

Expense incurred for the Judge: 6 Shillings
Payment to the executioner for his pains: 8 pounds, 14 shillings
Executioner's expenses: 16 shillings, 4 pennies
Hemp coats: 3 pounds 10 shillings
Making of the above: 8 shillings
Hangman's Rope: 6 shillings
Tar Barrel: 14 Shillings
10 loads of coal: 3 pounds, 6 shillings and 8 pennies.

King James was a keen theologist and so the belief of witchcraft caught his attention. He spent much of his time in Denmark learning as much as he could about the notion of this dark art and the methodology to identify it. By the time the royal couple set sail for Scotland in May 1590, he had learned much about the witch trials held in Denmark and was keen to take this knowledge home with him to Scotland. However, just as Queen Anne's initial attempts to reach Scotland had been thwarted by poor weather, their journey was hampered with great storms that seemingly rose out of nowhere and continuously forced the fleet back. After several attempts, they finally made it home, much to the embarrassment of the Danish authorities, who were keen to find a reason for the failings. A Danish minister was accused of deliberately understocking the ship, resulting in it becoming unstable and unable to withstand the storms. Quite possibly due to the king's interest in witchcraft during his time there, the minister immediately pointed the finger of blame to a local woman, claiming she had used witchcraft to replace full barrels with empty barrels on the ship, resulting in the instability. The accusation was enough to send her to trial and, no doubt as a result of the torturous interrogation methods as laid out in the *Malleus Maleficarum*, she not only confessed to have been responsible for trying to sink the king's ship, but she went on to name other women she said had worked with her, including a one named Anna Koldings, known locally as the Mother of the Devil. This nickname indicates she was an unpopular lady for some reason, and the witch trials gave the perfect opportunity for local communities to rid themselves of those they did not like. The women, under interrogation, confessed to have also cast spells to try to sink Queen Anne's ship on her initial voyage to Scotland, after which thirteen women were burned at the stake for being witches.

James had his answer, along with evidence obtained through the Danish justice system that the reasons for the failed voyages was down to witchcraft. Curious as to whether anyone in Scotland could also have been responsible, possibly working with the Danish witches, he launched an enquiry, the result of which was a two-year-case

The 'scolds bridle', a device often used during the witch trials. The cage would fit over the head and a sharp prong fixed into the mouth, preventing the wearer from speaking. (Courtesy of History and Horror Tours, Perth)

known as the North Berwick Witch Trials, which would see around seventy men and women accused of witchcraft. If this wasn't enough to convince the people of Scotland that witchcraft was real, the king personally oversaw several of the trials and torture sessions before his own book on the subject – titled *Daemonologie* – was published in 1597. To dispute the existence of witchcraft would mean going against the word of both the Church and the king.

Many communities at this time were walled, with few ordinary people travelling outside their own community. Increasingly, therefore, any misfortunes of natural incidents such as ships sinking, storms, floods, failing crops, illness and so on were all

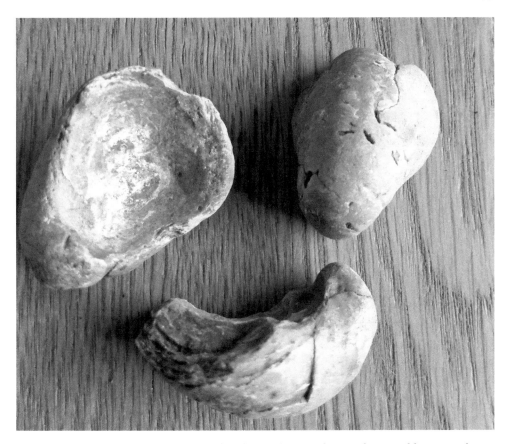

The gryphaea fossil, believed to be a sign that the Devil was in the area due to its likeness to claws.

blamed on witchcraft and aroused suspicion within towns. A fossil known as a gryphaea formed from an extinct species of oyster used to be a relatively common find on the beaches of Scotland, yet as these look very much like a claw, they became known as 'Devil's Toe Nails'. To find one on the beach was seen as proof that the Devil was in the area, preying on the weak-minded and making them do his bidding. Paranoia began to sweep through towns, with neighbours turning on neighbours, and anyone who was unpopular or disfigured coming under scrutiny. The elderly were particular targets – those who had outlived their useful purpose. It was, on reflection, a very sad time.

The treatment of those accused was often very public. The interrogation sessions allowed for torture to be used for a confession where one was not given freely. The initial stages would be sleep deprivation, such as the walking of a witch, were common. This was when a rope would be wound and tied painfully tightly around the head of the accused and they would be led by this rope and forced to walk non-stop around their cell. Guards would take shifts in this, to ensure there was no rest for the accused. Whenever breaks were taken devices such as the 'Witches Fork' – a metal bar with two sharp spikes that fits under the chin and onto the breast bone – would be used. This device forced your head back into an uncomfortable position, making it impossible to move your head without

the spikes digging into the flesh of your chin or chest, so sleep remained an impossibility. If the physical and psychological effects of sleep deprivation were not enough to force a confession, other means would be used, including the thumb screws, better known as the 'pilliwinks' in Scotland. These would be used to not only crush the thumbs, but other fingers and toes also. The 'booties' were another device, which consisted of a wooden or metal boot into which the feet and lower limbs were placed before metal spikes were hammered in, crushing the ankles and legs.

The witch trials became so lucrative that some people forged careers in finding witches. The most common role was that of the witch pricker. It was believed that when you became under the control of Satan he would remove your baptism and replace it with a baptism of his own. This would appear on the body in the form of a mark, such as a mole or a birthmark. Despite being incredibly common, these were enough to show you were in league with the Devil. It was believed that no pain could be felt at the Devil's mark and the pricker's job was to push a long, thin spike into suspicious marks on an accused's body to see if they felt it. Of course an experienced pricker would work around the area first, numbing it, before driving the needle into the mark in the centre. Even if no marks were visible, that would not rule out the possibility that the Devil's mark was within you, and the pricker would systematically push the spike into the flesh to try to identify an area where no pain was felt. Again, this could be achieved by numbing an area, but as the witch prickers were paid for their time, it was not in their interest to speed up the process.

It is clear to see that the fear of being accused of witchcraft would have been enough to make most women remain subservient, as they had been prior to the Reformation, to avoid drawing attention to themselves. This fear spread across families due to the following wording from the 1563 Witchcraft Act, which can be found in multiple sources:

> Nor that na persoun seik ony help, response or cosultatioun at ony sic usaris or abusaris foirsaidis of Witchcraftis, Sorsareis or Necromancie, under the pane of deid, alsweill to be execute aganis the usar, abusar, as the seikar of the response or consultatioun.

Roughly translated, the above wording means that anyone who is seen to assist, consult with or help an accused witch will be considered a witch themselves and shall be executed with them. The result was that if a member of your family was accused you could not be seen to offer any support or assistance to them, else you would find yourself in the prison cell with them, facing the same treatment, and ultimate end. For the loved ones of those accused the only intervention possible was to pray, thereby pushing people back to the Church.

Such was the fear, towns started to employ witch watchers, who were tasked with the role of simply watching everyone and reporting anyone who raised any suspicion in the way they acted. Any sign that anyone was using the old traditions or failing to attend Church at the allotted times, or even working on a Sunday, was enough to get you reported. Therefore, the emphasis once more was to get people to fall in line with the desires of the Church. Those who did want to follow old beliefs were forced to do so in dark corners of the town, further adding to the belief that what they were doing was wrong, and the work of the Devil.

Sadly, records of the witch trials are somewhat scant and those we do hold are often incomplete, with little detail on exactly what people were accused off. It is also often mentioned that people were accused with others, yet the names of these others are not even reported. Whether this was a deliberate act to conceal the truth of these terrible times, or whether it is simply a case that the lives of those unfortunate enough to find themselves accused were deemed so worthless that they did not warrant recording remains open to question. Personally, having read historic books that refer to the accused in derogatory terms such as stating they are 'wretched creatures', and other books that mention records being hidden and destroyed with only a few saved, my belief is it was a mix of both.

Stirling did not see the same levels of witch trials and executions as other towns in Scotland such as Edinburgh, St Andrews and Glasgow. This is not a reflection on the lack of importance of Stirling, but perhaps a sign of the town not having the same religious influences as others. Although, it has also been suggested that the authorities in Stirling were somewhat frugal with their spending, opting to be more lenient on those accused rather than spend the money to force a confession.

The earliest recorded case in Stirling is that of Isobel (or Isdobell) Murray in 1592. The case of Isobel itself is not documented, but her name comes up in a case of libel of an unnamed woman. Piecing together the information that is available, a local woman was accused by another woman of being a witch and, in response, she and her husband brought libel action against her accuser. This in itself indicates they must have come from an influential family, as it seems the accusation was not investigated. In addition, the accused proceeded to not turn up to two successive hearings, and only eventually turned up on the third occasion – again, the sort of action that would not be tolerated from the ordinary person. The case was thrown out of court and that should have been the end of it; however, seemingly in retaliation, the husband of the accused claimed that their accuser had consulted with a convicted witch named Isobel Murray. Under the terms of the 1563 Witchcraft Act, consulting with a witch would result in execution. This counter claim was heard by James Graham, Baillie of Kincardine, although it was held in Stirling. When considering the evidence, he found that while Isobel Murray had been accused of witchcraft, she had been found not guilty at her trial. On that basis, he ruled that any consultation with her had not been with a convicted witch, and so there was no case to answer.

In 1597, a letter written by King James himself gives details of other accused witches in Stirling. In the letter he refers to simply 'the witch', but on the basis of other content from the letter this is believed to have been either Elizabeth Hamilton, Catherine Kellot or Jonet Crawfurd (Janet Crawford), all three of whom are recorded in the Stirling Presbytery minutes as being accused of witchcraft in 1597. It appears it was in fact Robert Hamiltoun who was accused, and his wife was included within the case. Janet's husband, William, was later included in the accusations. While it is known that having been accused they were ordered to be held in Stirling for trial, and although there are no records detailing what happened to them or their ultimate fate, the king's letter suggests at least one of the unfortunate women faced an unpleasant end. It seems he had become frustrated at the Provost of Stirling's reluctance to deal with those facing allegations of witchcraft, and demanded that she be sent to his palace in Linlithgow immediately to be dealt with.

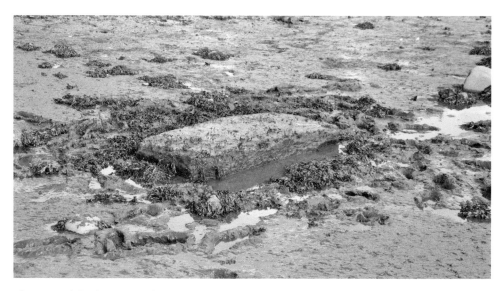

The grave slab of an accused witch, Lilias Adie, buried at the low-tide mark of the Firth of Forth, a short distance from Stirling, due to her dying before being convicted. (Courtesy of Fife Council Archaeologists)

On 6 May 1628, a gentleman named Adam Neilson stood trial in Stirling for consulting with a witch known as Stein Maltman. In another example of the town authorities' lenient views towards witchcraft, he was sentenced to repent for his misdemeanour in the church in front of the full congregation. On 3 July of the same year, Stein (Steven) was also charged with witchcraft. He was a well-known and much respected healer from Leckie, around 7 miles west of Stirling, better known as the 'Witch Doctor of Leckie'. He was accused not only of using supernatural powers to cure people of their illnesses, but of also transferring these illnesses to others. At his trial in Stirling he freely admitted his guilt, stating he had learned his ritualistic healing from the faerie folks. In Scottish folklore the faeries are not the lovely little winged fairies we are used to from modern stories, but rather spirits deemed too bad to go to Heaven but too good to go to Hell, so were stuck in a middle world, which became known as the Faerie World. Stein gave a detailed confession of his methods of curing the sick, and would have almost certainly been found guilty as a result. The records do not, however, indicate what the eventual outcome was.

After years of relatively minor cases of witchcraft, Stirling's involvement with witch trials was to take a sudden upturn in 1659. When William Lucisone fell ill he consulted a local healer named Magdalen Blair with the full knowledge that she was already under suspicion of witchcraft, having been accused by her neighbour. She asked if he had ever had any relations with a woman named Isobel Bennet, another suspected witch, to which he replied that her chickens were often found running loose on his father's property and that he had thrown stones at them on several occasions to scare them away. Magdalen is said to have instructed William to go to Isobel, grab her coat tail and drink ale with her, while demanding that his health be returned to him. It is not believed that William

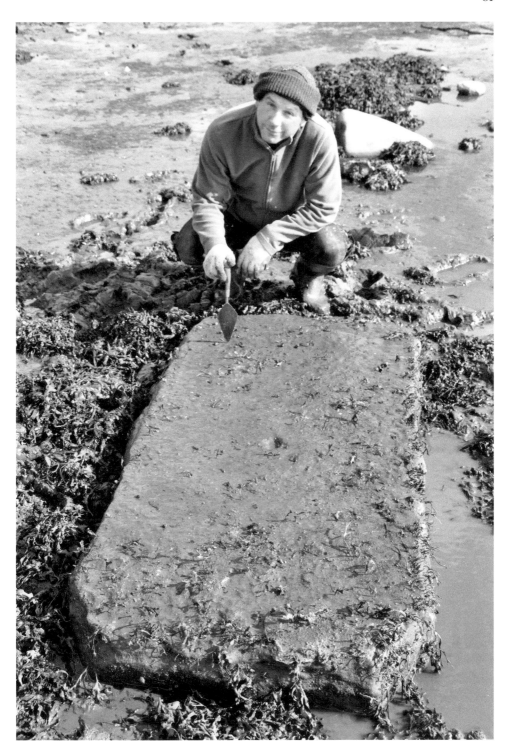

The grave slab of Lilias Adie.

carried out these instructions, however. As the enquiries into Magdalen and Isobel progressed, he became embroiled in a situation with allegations being thrown all around, naming different people as being practitioners of witchcraft. It does, essentially, seem to be a group of neighbours with grievances against each other airing their frustrations, with fatal consequences.

One of those accused was a woman named Bessie Stevinson. Described as being of simple mind, she was often found at the ancient well, now known as St Ninians Well, which was one of the principal water supplies to Stirling. Here she would make charms as well as washing the clothes of the ill in the pure waters of the natural spring, before instructing them to be returned and worn immediately to pass the diseases from the person back to the water and the earth. It seems Bessie had been doing this for some time, no doubt right under the noses of the authorities, yet they had turned a blind eye rather than get involved; however, now she was implicated in a much bigger case, action had to be taken. Unfortunately, this seems to have lured Bessie into a false sense of security and confidence which, combined with her lower intelligence, resulted in her freely discussing during her trial how she would make her charms, trinkets and herbal remedies to cure the ill.

With an open confession in such a prominent case, there was no option but to treat Bessie under the law as set out in the Witchcraft Act, and she was sentenced to be burned at the stake. Magdalen Blair, by throwing accusations at others, who all then started to blame each other, managed to get herself released on a not-proven charge. Isobel Bennet faced a public flogging before being shamed further by being made to walk through the town, showing her injuries to all. Elspeth Crockett, Catherine Black and Margaret Gourlay were banished from the three kingdoms that fell under the control of the king. James Kirk and Margaret Harvie were released without charge, and Isobel Keir joined poor Bessie in the flames.

St Ninian's Well.
(© Euan Nelson,
cc-by-sa/2.0)

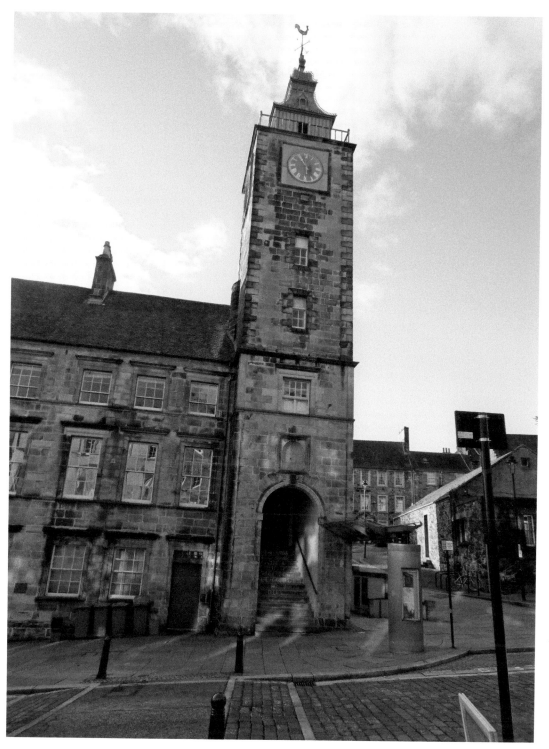

Stirling Tolbooth. The present structure was built after the witch trials, although it was constructed on the site of the earlier jail.

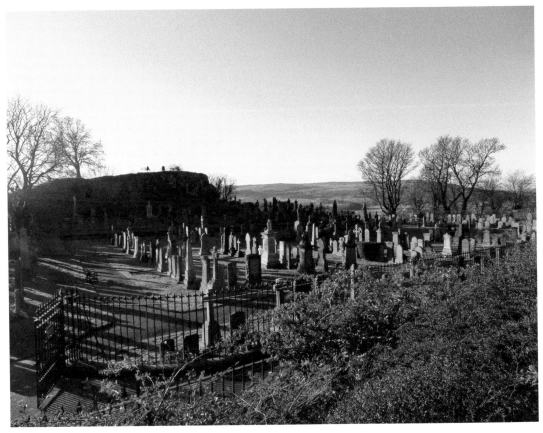

The Valley in the Old Cemetery (not a part of the cemetery) was the burning site for witches. It was considered to be far enough away from the town and castle to allow the fires to be lit.

In 1677 another multiple case of witchcraft arose for the Stirling baillies to deal with. The two sons of Douglas of Barloch, a noble family from close to Glasgow, tragically drowned while crossing a river. Janet Douglas, a woman who claimed to have the gift of second sight and who avoided prosecution herself for witchcraft by using her skills to identify other witches, convinced Barloch that the drowning had not been a fatal accident as believed, but instead had been the work of witchcraft. Enquiries commenced and soon John Gray, Janet McNair, and husband and wife Thomas and Mary Mitchell found themselves in Stirling Tollbooth, charged with causing the death. While imprisoned, in addition to other torture methods, all four are known to have endured the agony of the witch pricker, who successfully found marks on each of them to implicate them as disciples of the Devil. Janet McNair, it seems, was first to break under their horrific treatment, confessing to have got the marks after being gripped tightly by a fearsome dark man and that she had been in considerable pain from them for some time after.

As Barloch had brought the charges personally, he was responsible to the costs of the trial. After the four accused had been held for fourteen weeks with only one confession, which was not really sufficient to prove involvement in the drowning, he decided that

he could no longer meet the expense of their detainment and submitted a petition in July 1677 that the magistrates of Stirling should assume responsibilities for the ongoing costs. In response, the magistrates claimed that the town could not reasonably take on the financial burden and commissioned the Laird of Keir, Laird of Touch and Laird of Herbertshire to examine the case to determine whether there was any evidence to prove the crime of witchcraft. The eventual outcome is not recorded, although it is believed all four were quickly released with no charges against them. The actions of Janet Douglas were also reviewed and, considering her to be quite an inconvenience for bringing expensive trials to the county, she was banished for being a cheat and imposter. Initially no ship's captain would take her, such was her reputation, but eventually she was removed and it is believed taken to the West Indies.

The final witch trial in Stirling took place on 6 June 1683, when a local woman named Elizabeth Naismeth faced her judgement. Again, the information on what she is said to have done that resulted in her finding herself in such an unfortunate position is not documented. However, after a short trial, and in line with Stirling's general approach to the witchcraft hysteria, she was found not guilty and released. By this time the belief in witchcraft was declining, and the country was entering into more prosperous times.

The Witchcraft Act was finally repealed in 1736, by which time it was estimated that around 4,000 people had met their deaths on such accusations. Those facing trial in Stirling, although they still suffered horrific treatment, could consider themselves fortunate at the town's more lenient approach.

DID YOU KNOW?
Many people will have heard of 'dooking' a witch, the process where the accused was tied up and thrown into a pool if water. If they floated, they were guilty; if they sunk and drowned, they were innocent. In Stirling an alternative known as 'flying the witch' was used. Those unfortunate enough to find themselves on trial may have found themselves standing on the cliff edge at Witches Craig, where they were made to jump. If they flew, they were a witch, and presumably could escape, but if they fell to their death, they were innocent.

10. The Growth of Stirling

After the union of the crowns, and the later political alliance formed through the 1707 Act of the Union, the importance of towns such as Stirling declined as a royal residence since the monarchy based themselves in London. While some places struggled to reinvent themselves, Stirling did not suffer badly.

During the eighteenth century the population lingered around 4,000 and it remained a market town, with the small port for import and exports. During the Jacobite uprising of 1745, government forces based themselves in the castle, and while Bonnie Prince Charlie did not attack the town on his way south, he did when he returned to Scotland. It was a relatively futile attempt, however, and the guns set up to fire on the castle were themselves fired upon and destroyed before they could be used. Although it was not damaged, this was the final siege on Stirling Castle.

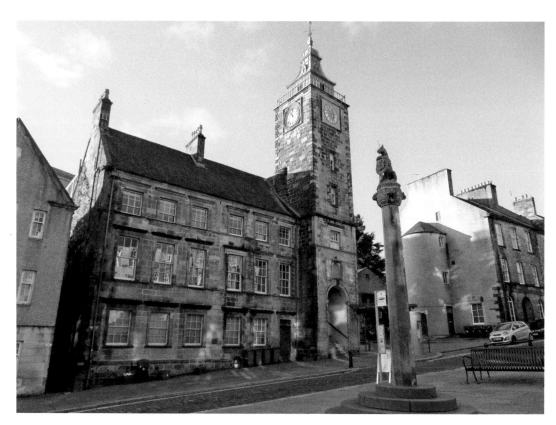

The town's Merket Cross, where the markets were held.

Plaque providing details on the markets.

DID YOU KNOW?
In 1820, twenty-two men were tried for treason in Stirling. As part of a movement known as 'the Radicals' the judge ruled that while most were to be deported, their leaders were to be executed. In front of a crowd estimated at 6,000, Andrew Hardie and John Baird were first hung for thirty minutes, before their bodies were cut down and beheaded – the last beheading in Stirling.

The Industrial Revolution brought little to Stirling, with the exception of wool-weaving and carpet-weaving businesses setting up. The population of the town also started to grow, with houses being built on the surrounding land. In 1777, the first bank was opened in the town and a piped water supply became available for those wealthy enough to afford this luxury.

By the start of the nineteenth century the population had grown to over 5,000, and by the 1820s this had grown to over 7,000. The town remained a predominately market town, but started to benefit from considerable improvements as it grew. Gas street lighting was

introduced and a new bridge was built across the Forth, improving transport links. In the 1850s, after a devastating epidemic of cholera caused by the poor sanitary conditions of the town, sewers were dug throughout the town. A new jail was also built, and a police force was established in 1857.

The arrival of the railway in 1848 further improved transport links and began to draw people to Stirling, both to live and to visit. In recognition of Stirling's historical importance and the growing tourist market, the Wallace Monument was built in 1869, and the Smith Art Gallery and Museum in 1874. In the same year, horse-drawn trams started to operate in the town, and the Old Arcade was constructed in 1882, providing trading facilities for local businesses. By the 1870s, the population of Stirling had grown to over 11,000, and by the 1880s that had increased further to over 14,000. By the end of the eighteenth century, Stirling remained a market town but was growing as a centre for tourism with links further north, leading to the town becoming known as the 'Gateway to the Highlands'.

In 1900, electricity became available in the town, and the population had grown to over 18,000. The first library was opened in 1902 and facilities for the townsfolk further improved in 1912 when a cinema opened. In the 1920s the horse-drawn trams were replaced by buses and the road network began to be improved for motor vehicles. Despite the expansion and new building work, some parts of the town remained dominated by slum housing, and throughout the 1920s and 1930s these were cleared and new housing constructed. Sadly, to make way for hew housing, many historic buildings in some of the oldest parts of the town were demolished.

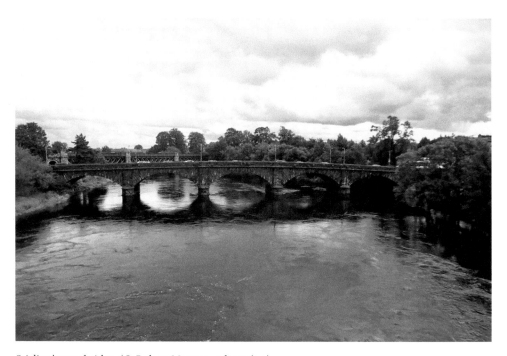

Stirling's new bridge. (© Robert Murray, cc-by-sa/2.0)

Stirling's new jail, now better known as the Old Town Jail.

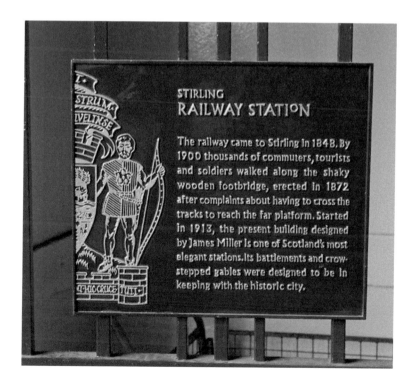

Stirling railway
station plaque.
(© Ian Taylor,
cc-by-sa/2.0)

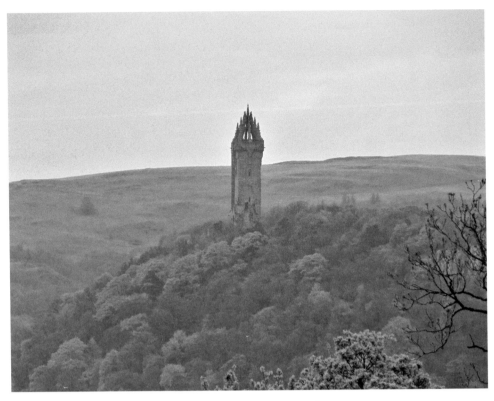

The Wallace Monument dominates the skyline for miles around.

The Smith Art Gallery and Museum. (© Richard Sutcliffe, cc-by-sa/2.0)

In 1967, Stirling University was established by royal charter. In the first year, 164 undergraduate students and thirty-one postgraduate students began their studies in Stirling. The university has grown considerably since then, now having over 14,000 students from more than 120 nationalities. The university was ranked fifty-fourth-best in the UK and eighth-best in Scotland for 2018. Some courses are excelling, with the criminology course, media and film studies, education and social policy all being ranked first place in Scotland, and sociology being ranked second.

In 2002, the importance of Stirling was once again recognised and it was made Scotland's sixth city. Today, much of Stirling's past has been celebrated, making it a popular destination for tourists in its own right rather than just as a stopping point before travelling to the Highlands. Although the city has managed to retain its relatively quiet and peaceful feel, with a population of around 48,000, it is now one of the fastest-growing cities in the United Kingdom, with more and more people moving to make the most of what Stirling and the surrounding countryside has to offer.

Airthrey Castle, a Victorian manor that sits at the heart of Stirling University. (© Bill Boaden, cc-by-sa/2.0)

With Stirling's historical importance being remembered, there are several statues to both William Wallace and Robert the Bruce. (© Gerald England, cc-by-sa/2.0)

The University of Stirling. (© Bill Boaden, cc-by-sa/2.0)

The Robert the Bruce statue at Bannockburn Battlefield.

DID YOU KNOW?
Stirling's last public hanging took place in 1843, yet it was no ordinary execution. Eighty-four-year-old Allan Mair was accused of beating his wife to death with his stick. According to some reports, he was too weak to walk to the gallows and so was tied to a chair and carried there before being hung, still attached to the chair. He somehow managed to fight his way free and attempted to hoist himself back up on the rope, leading to the executioner grabbing his ankles and pulling him down until his neck snapped. In the year 2000, a human skeleton found at the entrance to the tolbooth was found to be that of Mair, and his body was finally laid to rest.

Bibliography

Books and Publications

Anon, *A General History of Stirling* (C. Randall, 1794)

Anon, *A New Description of the Town and Castle of Stirling* (Ebener Johnstone, 1835)

Chambers, Robert, Domestic Annals of Scotland (Edinburgh: W & R Chambers, 1859)

Lawrie, John, *The History of Wars in Scotland* (Edinburgh: W. Darling, 1783)

MacLagan, Christian, *The Hill Forts, Stone Circles, and Other Structural Remains of Ancient Scotland* (Edinburgh: Edmonston and Douglas, 1875)

Oldridge, Darren, *The Witchcraft Reader* (Routledge, 2002)

Rogers, Revd Charles, *Stirling the Battleground of Civil and Religious Liberties* (James Nisbet & Co., 1857)

Sibbald, Sir Robert, *The History of the Sheriffdoms of Linlithgow and Stirling* (Andrew Stmson, 1710)

Thomson, James K., *A Bronze Age Cairn at Coneypark, Stirling* (Council for British Archaeology, N.K.)

Websites

The Survey of Scottish Witchcraft, the University of Edinburgh: www.shca.ed.ac.uk/Research/witches

About the Author

Gregor was born and raised in the town of St Andrews in Fife. Having been surrounded with history from a young age, his desire to learn about the past was spiked through his grandfather, a master of gold leaf work whose expertise saw him working on some of the most prestigious buildings in the country, including Falkland Palace. After talking to other staff in these monuments he would come back and recall the stories to Gregor, normally with a ghost tale thrown in for good measure.

Growing up, Gregor would read as many books as he could get his hands on about ghost lore, and going into adulthood his interest continued and he would visit many of the historic locations he had read about. After taking up paranormal investigation as a hobby, Gregor started to become frustrated at the lack of information available behind the reputed haunting. He has always felt it is easy to tell a ghost story, but it is not so easy to go back into the history to uncover exactly what happened, when and who were the people involved that might lead to an alleged haunting. He made it a personal goal to research tales, by searching the historical records to try to find the earliest possible accounts of both what had happened, and the first telling of the ghost story, before it was adjusted as it was handed down from generation to generation. This proved to be an interesting area to research and Gregor found himself with a lot of material and new theories about what causes a site to be allegedly haunted. After having several successful books published about the paranormal, Gregor found himself uncovering numerous forgotten or hidden tales from history. These were not ghost related, but were stories too good to remain lost in the archives, and he looked to bring the stories for specific towns together to tell their lesser-known history, often the darker side.

Gregor's first book in this area was *Secret St Andrews*, telling the long and often brutal history from his own neighbourhood and he has since written *Secret Inverness*, *Secret Dunfermline* and *Secret Dundee*.